About the Author

Sandra J. Blum, president of Blum & Co. in Fairfield, CT, special-izes in the creation and production of direct mail, sales and technical literature, and other forms of marketing communica-tion. Blum's company is a full-service ad agency and communica-tions consultancy that creates successful direct response programs for clients whose products range from computers to design magazines. The firm has also devised training programs for corporate clients such as Aetna, JP Morgan and Prudential/AARP.

Blum is experienced in graphic design and copywriting, and in all aspects of direct mail strategy, list selection, mailing services and print buying. She also consults on business strategies and market development. She is the coauthor of the CD-ROM *Mail Marketer: Grow Your Business Using the Mail* (a Pitney Bowes Best Practices Guide). She has also conducted business seminars to thousands nationally and internationally.

Designing Direct Mail That Sells. Copyright © 1999 by Sandra J. Blum. Manufactured in China. Published by North Light Books, an imprint of F&W Publications, Inc., 1507 Dana Avenue, Cincinnati, Ohio, 45207. First edition.

03 02 01 00 99 5 4 3 2 1

Library of Congress Cataloging-in-Publication Data

Blum, Sandra J.
 Designing direct mail that sells / by Sandra J. Blum.
 p. cm.
 Includes index.
 ISBN 0-89134-827-1 (hc. : alk. paper)
 1. Advertising, Direct-mail. 2. Commercial Art. I. Title.
HF5861.B568 1999 98-39467
659. 13'3—dc21 CIP

Editors: Lynn Haller, Chalice Bruce
Production Editor: Nicole R. Klungle
Designer: Angela Lennert Wilcox

For my husband, Edward, and my daughters, Ellen and Amy

Acknowledgments

This book is much richer for the generous contributions of a gallery of the world's greatest direct mail designers, and I would like to extend my deepest thanks to Richard B. Browner, Nancy Davis, Jyl Ferris, David Gordon, Ted Kikoler, Heikki Ratalahti, and, in particular, to David Wise and Alice Williams, who were especially encouraging. I'd also like to acknowledge a special group of my wonderful clients who have given me the privilege of working with them on some breakthrough projects and winning mailings: Uday Joshi and Pat Brand of Pitney Bowes; Steve Coffey of Media Metrix, Inc.; Dan Harding of Business and Professional Research Organisation, Ltd.; Dick Rosenthal, Budge Wallis, Jeff Lapin and Colleen Cannon of F&W Publications, Inc.; Dale Stern of Price Waterhouse; Andy Paul of Claritas; and Hal Clark, Garry Van Siclen and Scott Taylor of Trade Dimensions. My dear friends Mary Pretzer and Jill Townsend are my longtime creative sounding boards, and we've created some great offers and mailings together. The designs of Beth Crowell and Mark Cheung of CHEUNG/CROWELL Design and Monika Vainius of Nika LLC have been major contributors to the success of Blum & Co. And thanks to friend and sometime collaborator, copywriter Ron Marshak, for keeping me on my toes. To my editors, Lynn Haller and Chalice Bruce, my undying appreciation for their patience and intelligent editing. And last but not least, I am thankful for the world of direct mail, where we know what works because it wins. A legion of great direct copywriters and designers have paved the way for the rest of us!

Table of Contents

Why You Need This Book

or

If everybody just throws away junk mail, why does it account for 14.2 percent of total advertising spending?

In the design world, direct mail is like a neglected, poorly understood stepchild, starting with the other name by which it is fondly (or not so fondly) known, junk mail. And to most designers it *is* visual junk, meant to wind up in the dreaded round file. However, to direct mailers, the only aesthetic judgment that counts is if the piece gets a profitable response. Lots of direct mail is designed to be an intrusive, in-your-face, do-it-or-throw-it-away experience; this book is designed to tell you why.

D esigners aren't alone—most Americans have a love-hate relationship with direct mail. Most people say they throw away all their junk mail, but somehow almost everybody orders something from a solicitation received in the mail. Love it or hate it, direct mail is a big area of opportunity for designers. It certainly is commanding new respect from the top advertising agencies and large corporations—the $37.4 billion spent annually on direct mail represents 14.2 percent of total U.S. advertising expenditures and 24.4 percent of total direct marketing expenditures.

In 1997, business-to-business direct mail accounted for $145.7 billion in sales, while consumer direct mail sales equaled $244.3 billion. For 1998, those numbers are projected to be $160.2 billion and $261.1 billion, respectively. Between 1992 and 1997, direct mail advertising expenditures grew at an average annual rate of 8 percent. From 1997 to 2002, business-to-business direct mail is expected to grow 8.2 percent per year versus 5.3 percent for consumer direct mail.

Amazing Medium and Amazing Results

Direct mail is a unique blend of art and science. You have to mail to the right people. You have to have a great offer that motivates response. You have to package the offer in a way that gets the envelope opened and that gets the reply mailed, faxed, E-mailed or phoned in. Even before all that, your direct mail faces pretty formidable odds against getting into the hands of the right person at the right time. It can be stopped at the office mail room or ignored by consumers glued to the TV following a big news story. Despite this, direct mail is an amazing medium that brings in billions of dollars to the U.S. economy every year, and knowing what makes it tick can bring you (and your clients) profitable new business!

Direct Mail Advertising: A Growth Medium

Direct Mail Advertising Expenditures	1997	Projected 1998	Projected 2002	Compound Annual Growth 1997–2002
Consumer	$23.3	$24.7	$30.1	5.3%
Business-to-Business	$14.1	$15.3	$20.9	8.2%
Total Direct Mail	$37.4	$40.0	$51.0	6.4%

(In billions of dollars. Numbers have not been inflation adjusted.)
Source: *1997 Economic Impact: U.S. Direct Marketing Today*, The Direct Marketing Association.

There's More Growth Ahead

Technological advances and the growth of database marketing mean even more growth for direct mail. Large and small companies are building customer databases that include historical and other information, which allows them to categorize their customers for marketing purposes. Corporations with huge data warehouses are using database marketing and data mining techniques to segment their markets and to market smarter to small, profitable niches. The result is customized mailings, "versioned" for each market segment—and more work for designers!

Small businesses now have access to desktop database applications that make marketing by mail much easier for them, too. The car dealer around the corner, the specialty clothing store down the block or the illustrator working from home can keep a computerized mailing list easily, and all of them have the capability to create a pretty sophisticated marketing database from customer information. Mailing lists that used to require a minimum order of five thousand names are now easily available as smaller, more specialized lists on CD-ROM or the Internet. All these small businesses and home businesses will be looking for help from local designers to create direct mail to take advantage of their new abilities to mail to customers and prospects more easily—and if they're not, you may be able to persuade them that they should be.

Direct mail is also used by savvy companies to cement long-term relationships with customers. Typically they send thank-you letters, marketing newsletters, announcements, etc., to communicate with customers by mail about once a month. All of these mailings are devised as part of a relationship marketing plan. Each individual mailing may not bring in more profits, or even a response, but customers targeted in a relationship marketing program have been proven to spend more over time and to remain customers longer.

According to the marketing gurus, advances in technology will make one-on-one marketing the next logical step—the ultimate in target marketing. One-on-one marketing requires even more specific communications, reflecting the likes and dislikes of the individual.

All this adds up to OPPORTUNITY in capital letters—if designers can master the secrets of the medium.

Read This Book

In the pages that follow, you'll get inside secrets from the pros about direct mail creative. We'll look at some classic direct mail formats and elements, and how

the design of each works to promote response. You'll acquire new respect for the designer who can use a kraft envelope and a slip of 50# paper printed in two colors to generate millions of orders. You'll also understand why it's not too difficult to get a high response to a four-color, three-dimensional mailing with a clever premium inside. Throughout, you'll be challenged to think like a direct mailer. And then, as a grand finale, you'll meet and hear from some of the top names in direct mail design, who will share their wisdom with you.

Of course, putting words to all of this—describing the process—sort of takes the power out of it. Direct mail at its best is like a superb salesperson. When you are being sold to by a super salesperson, you forget you're even being sold to. It is so natural, it feels so good, so right.

Living Laboratory of Direct Mail Design That Works

or

The Basics Are in Your Own Mailbox

Designing direct mail that gets high response and is cost-effective is not intuitive--at least, for most people. And getting a high response rate at the highest contribution to the bottom line is what great direct mail design is all about--it's the only thing that counts! Luckily, there is a sort of living laboratory surrounding us to give us help: the direct mail you see at your home or office every day from companies who mail millions of pieces. Direct mail from these folks is the result of constant testing. So if you see a mailing several times in a year--or even better, see it again and again over a few years--it means that mailing has beaten everything tested against it.

While you personally may not like them, Publisher's Clearinghouse mailings look the way they do because that's what brings in the greatest number of responses for them. Subscription offers from magazines frequently come in 6" x 9" envelopes or on double postcards, not in #10 business envelopes, because that's what wins in tests. Business-to-business mailings for high-end products or services to upper management usually get past secretaries and mail rooms and get better response if they are more reserved, usually mailed in closed-face #10 business envelopes.

One of the reasons the elaborate 3-D packages you see in other books on creative direct mail can get high response in business-to-business mailings is that they get through screeners. And many times their creativity and memorability subtly demonstrate the superiority of the product or service being promoted. However, expensive packages that require hand processing and higher delivery costs tend to be appropriate for relatively small lists, for high-end products or services, or when it takes several months and lots of interaction to

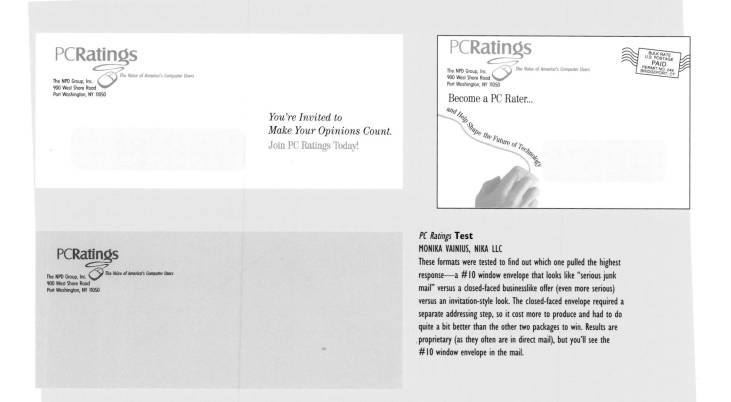

PC Ratings Test
MONIKA VAINIUS, NIKA LLC
These formats were tested to find out which one pulled the highest response—a #10 window envelope that looks like "serious junk mail" versus a closed-faced businesslike offer (even more serious) versus an invitation-style look. The closed-faced envelope required a separate addressing step, so it cost more to produce and had to do quite a bit better than the other two packages to win. Results are proprietary (as they often are in direct mail), but you'll see the #10 window envelope in the mail.

get the sale. In chapter eleven, we'll find out when 3-D and oversized promotions do make direct mail sense. But for the rest of the time, we'll focus more on the everyday direct mail we see around us and why it works.

Measurable Response

Simply put, direct mail is advertising mail designed to get a measurable response. And the measurable response tells you what works.

The mailer wants people to buy something, come into the business, send for more information, call, etc. How big or small the response is tells you if you sent the mail to the right people (i.e., rented the right lists, targeted the right customers). It tells you whether you made the right offer. It tells you if the way you made the offer—the copy and the design of your mailing—was appealing.

In order of importance, the success of a mailing depends on:

1. mailing lists

2. offer

3. copy and design.

But don't be misled by the order of importance. Copy and design can make a big difference in the success of a mailing. Design and copy changes can sometimes double or triple response. Doing direct mail successfully is one of those challenges where everything has got to be on target to get the greatest reward.

Copy and Design Tests

Large-volume mailers, especially consumer mailers, constantly try to beat their control. (The control is the mailing that got the best response at the highest profit per order in the last round of testing.) When the offer and the mailing lists are working, mailers will test a new package and creative concept against the control to increase response.

Another kind of testing large mailers do is try to improve a package that's working. They "play" with all the elements in the cost vs. response trade-off to try to increase profits. An example of such a test is determining if a mailing works as well without a brochure as with one. Mailers might also test to see if a change—maybe a different color of envelope or new envelope copy—will bring response back up for a winning package that is showing signs of "wear out." (If you want to know more about how testing works, don't miss chapter three!)

The fact that so much testing has been done for so long by large-volume mailers is wonderful, because by looking at what's in the mail and what gets mailed over and over, we get a set of observable results to use as a guide.

The Little Things Count

In fact, direct mailers have tested—or have opinions about—almost every element of a direct mail package, down to very small things. They know that if they use the word *you* and variations of it in the letter, they will usually get a

> "In direct response, the customer is the most important thing—not the product, not my design style. I submerse myself in an audience like preparing for a stage role. If I prepare correctly, I enter a project being more like the customer than myself, wearing their shoes. I can see the product or service with something like their eyes and current understandings. And see some of what they will see. This is key in my work; the more my promotional work can originate from within the customer's comfort zone and reveal product benefits from that location, the more likely I will boost response."
>
> — DAVID WISE
>
> Wise Creative Services, Ltd.

Words That Grab Attention

Announcing

Discover

Easy

Exclusive

Free

Guarantee

Health

Help

Immediately

Introducing

Know

Learn

Love

Money

New

Now

Powerful

Profits

Protect

Proven

Results

Safe

Save

Secret(s)

Today

Trust

Understand

You

Source: Starch INRA Hooper Research Worldwide

higher response rate than if they don't. They know that letters with a postscript (PS) will generally get a higher response rate than those without. They know that the word *free* is the strongest word in the English language and will get a consumer to open the envelope.

The Response vs. Cost Challenge

It bears repeating that profitable direct mail requires getting the highest response at the lowest cost. That may sound simple, but it's not. For example, sometimes a 9" x 12" envelope will be more cost-efficient than a #10 business envelope. Why? Because the extra response the 9" x 12" envelope gets pays many times over for the extra postage cost of mailing a nonstandard envelope. It's one of those things that gets tested!

Prospects—people who are not customers and so do not have a relationship of trust with a company—generally need better offers and more exciting mailings than existing customers. Since existing customers already know and trust the company doing the mailing, they will respond to direct mail that contains fewer bells and whistles. Sometimes even multistep mailing programs are required with prospects—the company sends a first mailing to get attention and follow-ups to get a response.

In determining how much to spend in acquiring a customer, sophisticated mailers also look at something called the Lifetime Value of a customer, meaning the profitability of a customer relationship over time. If the Lifetime Value of a customer is high, they may even lose money in the short run to acquire a customer, knowing that over the life of the relationship they will make a profit on that customer.

It's Not That Easy

You may think that if direct mailers would just send you a simple, straightforward, businesslike offer instead of all that paper, you'd evaluate it and respond equally well.

Don't worry—that approach gets tested. And if it won for every offer, that's what you would see! Start collecting the mail you get (and even better, your father's, spouse's and niece's mail too) and try to categorize it by what package design works for what audience and types of products, services and offers. Separate it into business-to-business and consumer mail and get a feel for the differences. Separate it by the kind of response the mailing is trying to generate:

- a completed transaction, like ordering or joining;

- a lead (where the responder can request and receive more information); and

- traffic (to motivate the recipient to visit a store, restaurant or other business establishment).

If you aren't a born direct mail design genius, there's nothing like a collection of great examples to help you learn from the experience of others, and to show you what's working *now*.

Direct Mail Is Different

or

Why All Those Die Cuts, Peel-off Stickers and Starbursts?

To paraphrase the great designer and author David Ogilvy, the first rule of direct mail design is: If it sells, it's creative.

Direct mail doesn't need to be tasteful or memorable. It's not a sin if it is; it just doesn't have to be. In fact, many mailers hold that tastefulness as commonly defined is a deterrent to response. Think about it. If direct mail does its job, you respond and throw it away. That's its highest compliment!

Direct mail pros know that response to direct mail is generally an impulse. And everything in the mailing should move you toward the decision to respond. As you scan the design and copy, an absolute crescendo of motivation should be created until you are pleading:

Yes! Rush me . . .

Yes! Send me more . . .

Yes! Sign me up . . .

Yes! I need . . .

First Principles First

It is absolutely essential to understand that direct mail is a "weak" medium. Weaker than personal selling. Weaker than telephone marketing. In a sense, weaker even than magazine advertising—there the reader at least selects and chooses to read the magazine. Direct mail's "weakness" is why it has to be intrusive.

People usually don't ask for direct mail to arrive at their home or office. Even though direct mail is (hopefully) targeted to a specific audience, you can't stand over the recipients and make them open your mailing—you have to entice them.

And direct mail designers have perfected hundreds of techniques that improve the odds people will read and look at what you want them to. But it's healthy to realize that design and copy have a big job. You can't send a salesperson along to answer objections or questions. Everything the reader needs to respond must be there, in view, immediately accessible. You, the creative team, have to get people to decide to do something—part with money or information about themselves, come in to a store or agree to attend—based only on the words they choose to read and what they decide to look at in the layout.

If they open the self-mailer, you can't control what they read first. If they open the envelope package, you can't control the order in which they choose to look at the individual components.

> "The critical difference between direct mail design and other advertising (in my opinion) is that most other types of advertising are simply for image or awareness and designed with a pretty slick look. It's not scientific. Direct mail, on the other hand, has one purpose only: to get an order. You have approximately eight seconds to convince someone to even open your envelope. Direct mail doesn't *have* to be pretty; it simply has to be convincing and effective. And it must *always* be about the customer—how his/her life will be better or how he/she will be more successful at crafting, decorating, remodeling, woodworking, etc., by buying your product."
>
> — NANCY DAVIS
>
> Meredith Corporation

Your challenge is to keep them from putting that mailing down. If they put it down, chances are it will never get looked at again. Your job is to keep them moving toward a decision to respond, no matter what they look at first, second or last.

Let Me See, Should I Open That Mail?

Direct mail faces some stiff competition for attention—bad weather, kids crying, a favorite TV show or office politics, deadlines, voice mail, E-mail. That's another big reason why it has to be intrusive.

In fact, it's healthy to realize that at any moment in time, only maybe 25 percent of the people who would be extremely interested in what you're offering are going to pay any attention at all to your mailing. The rest of them are out sick, on the road, too busy, too broke, etc., etc., etc., to react right now.

Because of all that competition for attention, direct mail design has to be "interruptive." It should "interrupt" whatever else the recipients are doing or is on their minds and say, "Hey, look at me! Have I got a deal for you!" or, "Hey, you'll find this to be of great benefit to you. Yes, you, personally. Pay attention."

The Secret Sales Power of Junk Mail

Hiding the fact that your mailing is advertising mail is often unwise, or even counterproductive. The virtue of classic direct mail design is that it looks like advertising mail. When people open something perceived as junk mail, you know that they are agreeing to be sold to or convinced. They are ready. They are in a "tell me and show me" kind of mood. You are designing to people who have just taken the first step to responding and you need to help them find what they need to make a decision—fast!

Just watch someone handling a classic direct mail package. Studies have shown it takes the average person seven seconds or less to decide to open the envelope and remove the contents. Then, in just eleven seconds or less, she looks at the response device, the letter, any enclosures and maybe the response device again. Why might she look at the response device twice? Because it has her name on it (people like their own names) and because it summarizes the offer and what she has to do. As she scans the mailing, she focuses on illustrations, headlines and subheads—only the things highlighted by some attention-getting device. And that's it. In just eleven seconds she has decided to do it or toss it. Of those who decide to "do it," some go back and spend more time with the mailing. Others phone, mail, fax or E-mail immediately.

You've Got 18 Seconds—Boom!

DESIGN: DAVID WISE, WISE
CREATIVE SERVICES, LTD.
COPY: JOSH MANHEIMER

This illustration shows the sequence in which the average reader looks at an envelope package. The whole process—from examining the envelope to making a yes or no decision—takes just eighteen seconds. Keep this "deadline" in mind as you design.

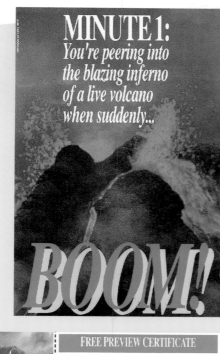

MINUTE 1:
You're peering into the blazing inferno of a live volcano when suddenly...

BOOM!

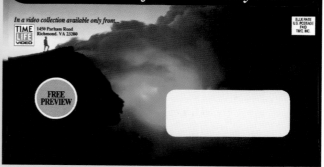

Witness the most remarkable nature footage ever recorded on film -- Absolutely Free!

In a video collection available only from...

TIME LIFE VIDEO
1450 Parham Road
Richmond, VA 23280

BULK RATE
U.S. POSTAGE
PAID
TIME, INC.

FREE PREVIEW

1 Front and back of envelope. Once your envelope is in your customer's hands, it has seven seconds (at most) to convince the recipient to open it. In this mailing for Time/Life video series, the recipient sees the words and the visual and—boom!—he's involved in a story. (And the die cut on the back of the envelope with the "FREE PREVIEW" sticker peeking out doesn't hurt, either!)

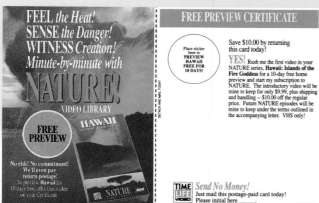

FEEL *the Heat!* **SENSE** *the Danger!* **WITNESS** *Creation!* Minute-by-minute with **NATURE!** VIDEO LIBRARY

FREE PREVIEW

HAWAII

NATURE

No risk! No commitment! We'll even pay return postage! To preview Hawaii for 10 days free, affix this sticker on your Certificate

FREE PREVIEW CERTIFICATE

Place sticker here to PREVIEW HAWAII FREE FOR 10 DAYS!

Save $10.00 by returning this card today! **YES!** Rush me the first video in your NATURE series, **Hawaii: Islands of the Fire Goddess** for a 10-day free home preview and start my subscription to NATURE. The introductory video will be mine to keep for only $9.99, plus shipping and handling -- $10.00 off the regular price. Future NATURE episodes will be mine to keep under the terms outlined in the accompanying letter. VHS only!

TIME LIFE VIDEO *Send No Money!* Just mail this postage-paid card today! Please initial here_____.

R/NVL191-2

2 Reply card. Readers often look for the reply card first because there's something intriguing about seeing their own name, and they'll usually find it here. Readers also know it's a good place to get a quick summary of the offer. And look—there's that "FREE" sticker!

Imagine standing within inches of bubbling, fiery, molten lava when suddenly...

BOOM!

Another blazing display of magma spews from the volcano just above you. And, as the river of liquid stone rushes toward the ocean, your eyes widen as you realize...

You are witnessing nothing less than the creation of earth...in the most spectacular display of raw natural force known to mankind?

May we send you
Hawaii: Islands of the Fire Goddess
to preview for ten days,
absolutely free?

Dear Friend,

With your permission, for ten days you and your family are about to journey to the most isolated place on earth -- absolutely free.

To enter ancient caves sculpted by lava where mysterious wall engravings bear witness to a thriving civilization long ago.

To streak across the savannahs of Africa narrowly escaping a bloodthirsty pride of lions ...

To plunge into the frozen arctic sea and chat with beluga whales. Climb over 14,000 grueling feet to the mist-shrouded world of the rare mountain gorilla.

In short, to behold the most exhilarating nature footage ever recorded on film ...

TIME LIFE VIDEO

3 The letter. Obviously a direct mail letter is not a personal letter, but it still conveys a feeling of person-to-person communication. This letter picks right up where the envelope left off, engaging the reader in an exciting story. Throughout the four-page letter, key points, including reassurances that this is a no-obligation, absolutely free preview, are highlighted using blue type, underlining, bulleted lists, etc.

4 The brochure. Most people go to the letter first, but some start with inserts like this brochure. Gorgeous photography and quick, thrilling copy pull the reader from fold to fold. When the piece is fully unfolded to a picture of a bubbling, fiery volcano, the reader is invited to "Take the Plunge!" with copy detailing the free preview offer.

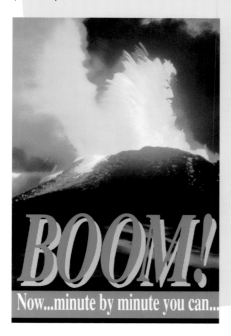

BOOM!
Now...minute by minute you can...

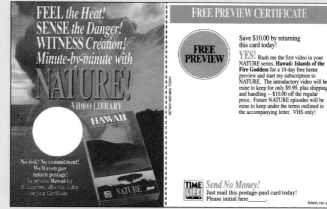

FEEL *the Heat!* **SENSE** *the Danger!* **WITNESS** *Creation!* Minute-by-minute with **NATURE!** VIDEO LIBRARY

FREE PREVIEW

HAWAII

NATURE

No risk! No commitment! We'll even pay return postage! To preview Hawaii for 10 days free, affix this sticker on your Certificate

FREE PREVIEW CERTIFICATE

Save $10.00 by returning this card today! **YES!** Rush me the first video in your NATURE series, **Hawaii: Islands of the Fire Goddess** for a 10-day free home preview and start my subscription to NATURE. The introductory video will be mine to keep for only $9.99, plus shipping and handling -- $10.00 off the regular price. Future NATURE episodes will be mine to keep under the terms outlined in the accompanying letter. VHS only!

TIME LIFE VIDEO *Send No Money!* Just mail this postage-paid card today! Please initial here_____.

R/NVL191-2

5 Reply card. (Again.) Your reply card gets looked at several times, so make sure it encourages the reader to respond. In this case, it's easy—all the reader has to do is place the sticker in the circle, initial and drop it in the mail!

World Book Encyclopedia

RICHARD B. BROWNER, RICHARD BROWNER, INC.

"My advice to designers in direct mail: Learn to read the copy. See what you can do to make it visually exciting and dramatic. Often the writer will put words down on paper—good words, strong selling words—without giving any thought to their visual potential.

"In this case, Linda Wells had written copy for our mutual client, World Book Encyclopedia. She had used the word 'go' several times at the beginning of several headlines (WBE was, at the time, attempting to diversify into travel), with no particular visual emphasis in its typewritten form, but with the clear intent of establishing a verbal rhythm. I suggested using the word 'go' as a visual element, large and bold and repetitive. The word acted as the connective tissue between components within the package."

A Charter Membership Invitation to get up and GO!

The World Book Travel Club
WORLD BOOK ENCYCLOPEDIA, INC.
Merchandise Mart Plaza · Chicago, Illinois 60654

CHICAGO ILLINOIS

Blk /Rt
U.S. POSTAGE
PAID
Permit No. 3899

GO!
Go North, South, East, West, sea to shining sea!

GO!
Go farther, go cheaper, go carefree!

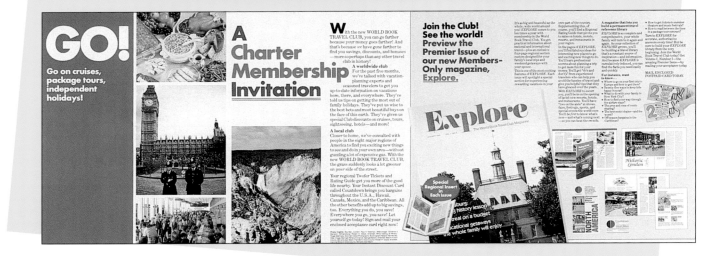

So here are the facts. Direct mail design has to be able to engross the reader and get her to part with money or her name and address in eighteen seconds or less! That's some challenge.

The Enemies: Boredom and Distrust

The visual clutter that offends the aesthetic sensibilities of so many designers is no accident. There is method to this madness. A maxim of Lewis M. Smith, former creative director of Wunderman Worldwide and marketing director of the Book-of-the-Month Club, sums it up, "Neatness rejects involvement."

The rhythm, the eye path, the push and pull of a typical direct mail piece is meant to involve the reader, to keep her finding the bits of information that the rational mind requires. It also appeals to fear, greed and other basic human impulses that the irrational mind responds to.

If at any point the mailing bores, if it doesn't keep commanding attention and involvement, it's all over.

If at any point the copy or the design triggers distrust, again you've lost the game. Direct mail design has to keep overcoming any doubt, however momentary, the reader entertains.

Why All Those Die Cuts, Peel-off Stickers and Starbursts?

It's all semiotics—signs and symbols functioning in a constructed advertising "language," so to speak. Die cuts, peel-off stickers, starbursts and all the other standby direct mail signs and symbols either demand involvement or signal a deal. The involvement they promote helps keep a person on the decision track.

A die cut on the envelope and a FREE sticker peeking through is like a siren call to most human beings.

Starbursts scream symbolically, "deal, deal, deal!"

YES and NO stickers say, "OK, make up your mind. What else do you need to decide YES?" Psychologically, perhaps having the NO next to the YES reassures the responder that the offer is credible, legitimate.

Let's See Direct Mail in Action

In this chapter, you've gotten some grounding in what direct mail is all about, but we've still barely scratched the surface. You've been introduced to some of the whys and wherefores of what makes direct mail design different; now let's see more about how those whys and wherefores turn into rules and how real direct mail package designs generate selling power.

Direct Mail Testing

or

There's Only One Rule in Direct Mail

The words "direct mail" and "test" are almost synonymous. Direct mail is *the* testable advertising medium. You send out the mailing and, in a relatively short time, the quantity and quality of responses tell you if you have a winner or a loser.

Once you have a winner, you can try to increase response (or to lower costs while meeting profitability goals) by changing some aspect of the mailing.

Or you can test an entirely different creative concept ("new creative," in direct mail talk) to see if you can beat the winner.

Large-volume mailers--national magazines or businesses like IBM or American Express--test extensively. If you do work for them, you'll need to know the basics of direct mail testing and what will be expected of you. If you are creating campaigns for clients who are new to direct mail, you can help them understand the role of testing.

It's also important for you to get results of mailing tests from your clients or from the marketing department if you work in-house. Your direct mail portfolio will be much stronger if you can cite the results your work garnered in mailing tests.

Beating the Control

The control is the mailing (the creative and the offer) that has beaten whatever has been tested against it. Smart mailers measure the control's success not only in terms of absolute response but also in terms of the cost-effectiveness of the mailing, and perhaps even the Lifetime Value (or long-term profitability) of customers acquired with the mailing.

Beating the control is the objective of a lot of testing. Mailers know that over time the control generally loses its power to generate as high of a response as it once did. The target audience gets used to seeing it. Or the look or the wording gets outdated. (There are a very few extraordinary exceptions where the control has lasted five, ten, even twenty years.) When mailers see signs of what's called "wear out," they decide it's time to try to beat the control.

A mailing created to test against the control may only have new copy and design or it may also have a new offer, new pricing, new premiums—any combination of new elements. Of course, if everything is changed and the new package wins, you don't know exactly which specific change increased response. To see the exact effect new creative has on response, it's necessary to keep the offer and the mailing lists the same.

Besides new creative, mailers test other things. Price testing is done to see if you can raise prices without decreasing response or if by lowering prices you can increase response. Sometimes a price increase may be tested with the expectation that, while response will decrease, overall profitability will increase. Surprisingly, test results sometimes show you can raise the price and raise response. Maybe it's because people perceive the product or service as being more special, more valuable.

Some mailers even test things like whether stating prices in whole dollar amounts ($20 vs. $19.99) has a positive or negative effect on response. The common wisdom in direct mail is that even numbers and whole dollar amounts

"**C**reative" is the direct mail term for copy and design. Previously mailed packages with a known response are called "existing creative." "New creative" is the term applied to new concepts designed to be tested. You're usually testing the "new creative" against the "existing creative."

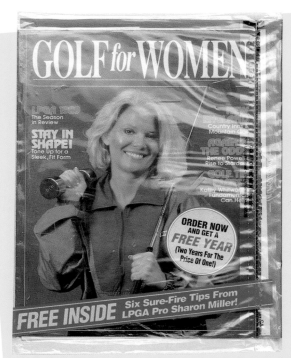

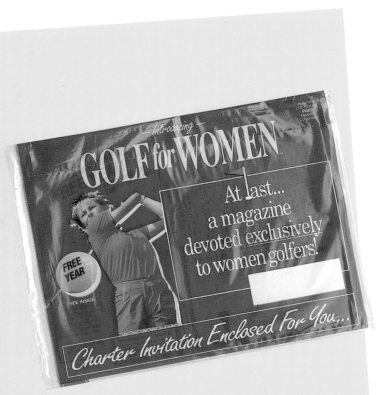

Golf for Women

NANCY DAVIS, MEREDITH CORPORATION

The green poly (back and front, above) was Meredith's launch package after the purchase of this magazine from its founders. It tested against their control package and pulled two to one. This was in 1990. "How Sweet It Is" (front and back shown below) is the current control and has proved very strong. It's held up for two or three years now.

It's interesting that the package that looks more like a mailing and less like a magazine is the control. The copy platform is the one that resonates most strongly with the audience. And the photo sure taps into a feeling that every woman who ever golfs with a man must experience. The headlines hit you like boom, boom—right into the big "FREE YEAR" arrow leading into the recipient's name. The subhead on the bottom clinches the concept and leads you right inside.

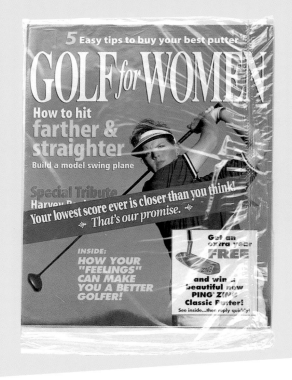

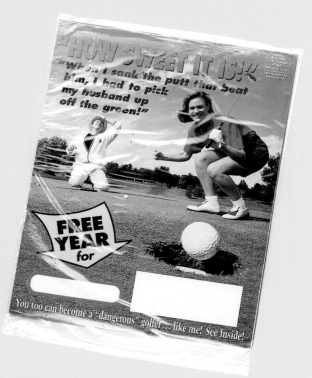

seem like less of a bargain and get less response. But a lot of money in direct mail has been made by challenging the common wisdom.

Element testing is done to see if a change to one element of the control mailing can raise response or improve profitability. For example, if response to an envelope mailing is declining, you can simply change the envelope and that can bring response back up to acceptable levels.

Test Cells

A direct mail test is only reliable if the testing process is sound, something designers can't usually control. However, it's essential to understand that in testing, the various versions are mailed to subsets of the mailing lists called test cells (also called test panels). And learning a little bit about the basics of testing will help you understand test results.

New creative and changes in offers or prices should be tested on lists that already have proven productive for the mailer. If a new package is tested on a new list, you won't know whether it was the change or the new list that affected the mailing's results. Launches or new business mailings are a different story, of course. There you are mailing untried creative to untried lists to see if there's a market.

Although it may not always be feasible, all the test mailings and the regular mailing should "drop" (be mailed) on the same day from the same postal facility.

Many experienced mailers have a rule of thumb that the test has to beat the existing control by at least 10 percent to be considered the winner.

Beating the control is a big claim to fame in the high-rolling direct mail game. A lot of newcomers to the business have made their reputation by beating a control done by a big-name direct mail copywriting/design team.

Testing and You

The only real rule in direct mail is *test!* Those hundreds of thousands of tests of new creative are how direct mail design techniques and all those "rules" evolved. Yet, on the other hand, weird and wonderful winning creative concepts—like peel-off stickers, L-shaped response cards and teaser copy like "The favor of a reply is requested"—would have never seen the light of day if it weren't for testing. Testing allows you to break the rules, too. The more experience you get at direct mail and the more winners you design, the more you get to call the shots.

The Right Outer Envelope
Men's Journal Magazine Outer Envelope Text
DAVID GORDON, DAVID GORDON ASSOCIATES, INC.

A general rule in direct mail is to test only what really counts—the big things that make a big difference. Outer envelopes fall in the "big things" category. Here are nine outers designed by David Gordon that were tested by *Men's Journal* against its control. As the results under each 6" x 9" envelope show, seven of the nine test envelopes did significantly better. However, the magazine decided against going with the envelopes with the more blatant sexual appeal even though response was high. The mission of *Men's Journal* is much broader—health, fitness, lifestyle—and the magazine wanted the appeal to be more than just sex. In this case, finding the right envelope was more than just a matter of raw results; you may see the Harley-Davidson envelope in your mail.

1 percent increase over control

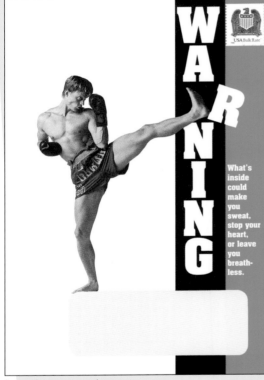

1 percent increase over control

19 percent increase over control

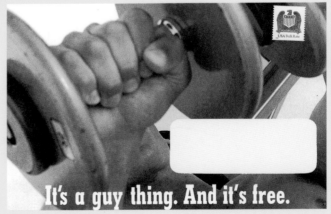

21 percent increase over control

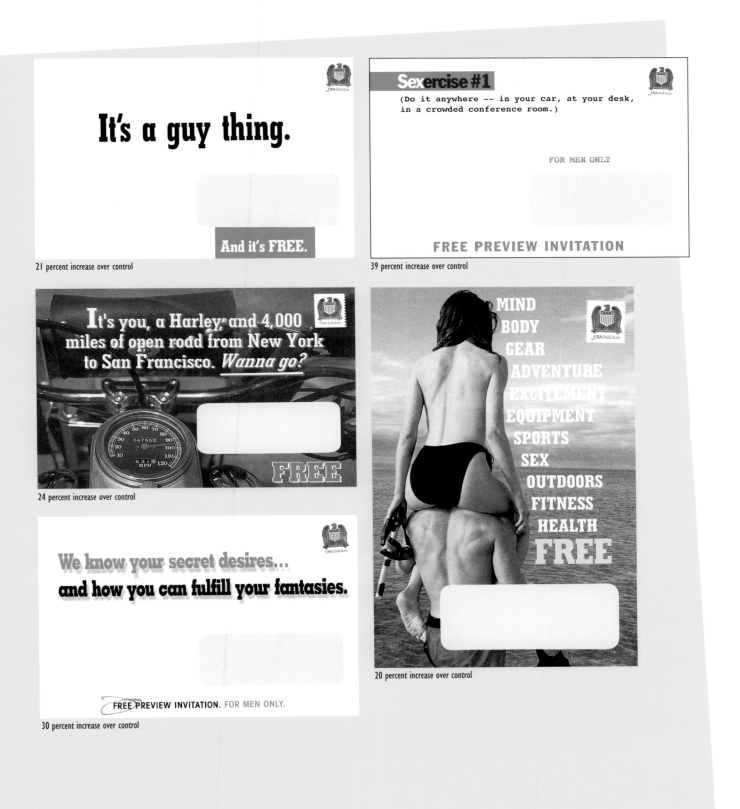

It's a guy thing.

And it's FREE.

21 percent increase over control

Sexercise #1

(Do it anywhere -- in your car, at your desk, in a crowded conference room.)

FOR MEN ONLY

FREE PREVIEW INVITATION

39 percent increase over control

It's you, a Harley, and 4,000 miles of open road from New York to San Francisco. *Wanna go?*

FREE

24 percent increase over control

We know your secret desires... **and how you can fulfill your fantasies.**

FREE PREVIEW INVITATION. FOR MEN ONLY.

30 percent increase over control

MIND
BODY
GEAR
ADVENTURE
EXCITEMENT
EQUIPMENT
SPORTS
SEX
OUTDOORS
FITNESS
HEALTH
FREE

20 percent increase over control

Classic Direct Mail Packages

or

When to Use What

Each familiar direct mail format--envelope mailings, self-mailers, catalogs, magalogs--telegraphs a different message. Even before they read one word, recipients have a preconceived notion of what is to come, and that's part of the power of each format.

Postcards

Postcards say "Good news, easy decision, this won't take much time." Because there's very little space to describe and promise benefits, postcards work best with low-risk, soft offers. (A soft offer requires no commitment and no money changing hands.) Postcards may pull in a lot of responses, but they could be of low quality because of the soft offer. Converting a lead (making a customer out of the respondent) or getting paid might prove to be difficult.

In the publishing business, double postcards (half postcard, half Business Reply Card) touting a trial subscription and one or more free issues of the magazine have proven to be a powerful way to keep costs low. However, the general experience is that fewer subscribers pay up, and of those that do pay up, fewer renew than with other formats and less lucrative offers. When the same offer is made to two test groups—one via double postcard and the other via a traditional direct mail envelope mailing—mailers often see poorer long-term profitability from the group solicited with the double postcard. However, like all things in direct mail, it's one of those things to be tested.

PC Gamer
Double Postcard
IMAGINE MEDIA
Imagine Media finds double postcards created in-house to be cost-effective. They've used them almost exclusively for their magazine launches. While double postcards usually work better for "household name" publications, they work for Imagine because their publications are targeted to people with very intense interests.

A free issue, a free CD-ROM or some other great offer is played up in the design along with the cover of the publication. The name of the publication immediately piques the audience's interest and the free offer gets them to try it. Imagine has tested a variety of direct mail devices—faux stickers highlighting the offer, certificate looks to connote value, and sweepstakes offers with pictures of the car or trip you might win. Peel-off stickers that the responder moves to the reply card have worked well.

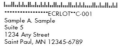
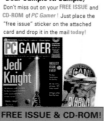
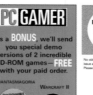
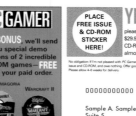

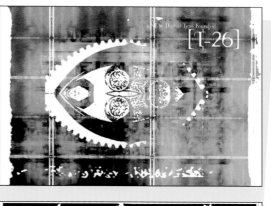

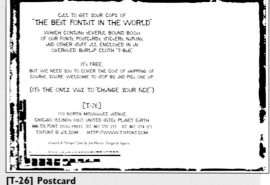

[T-26] Postcard
DESIGN: SEGURA DESIGN
"Free Font Kit Offer: All you have to do is call or stop by to get one." Eye-tracking study after eye-tracking study shows that as people scan a mailing the word *free* is seen no matter how small it is or where it is positioned. That isn't a license to set it in 6-point light gray type, but it does tell you how powerful the word is.

Self-Mailers

Self-mailers, although they have more copy space than postcards, also tele-graph that it won't take much time to see what they're all about. The decision to respond is often based on glancing at the front and back. Self-mailers are widely used for seminar and conference mailings, single book sales, lead-getting offers, and traffic-building offers to get people to visit a store, restau-rant or other business establishment.

One of the biggest bonuses of self-mailers in business-to-business market-ing is that they have great "passalong" value. "Passalong" means just what it says. People pass along self-mailers to other people they think will be or should be interested in the offer. In the seminar business, half or more of the attendees at an event may be there by virtue of passalong. Self-mailer copy and design should focus constantly on:

- benefits, benefits, benefits;

- the ease of response; and

- the low-risk or no-risk nature of the offer.

Self-mailers are extremely easy to set aside, file or throw away, so getting people to decide *now* is important to the mailing's success. Ease of response, time limits, low risk, etc. need to be visually emphasized.

Claritas MAX³D Self-Mailer
MARK CHEUNG, CHEUNG/CROWELL DESIGN
This business-to-business self-mailer used a sweepstakes offer to get the reader to take a look at innovative mapping software. Business-to-business sweepstakes are hard to pull off because the prizes tend to benefit the business, not the person who responds. But this very targeted mailing brought in a 30 percent response rate, and a high percentage of the leads converted to sales.

A black cover was used for drama, to attract the businessperson, and because the headline played on "black and white." The key to getting the self-mailer opened was the word "Sweepstakes" in red and the prize amount, teasing with a consumerlike offer and typographic approach. A short fold on the nonaddress side was used to promote flipping the cover up. The self-mailer's 5¼" x 11" size stayed within USPS maximum dimensions for letter-size mail (6¼" x 11½").

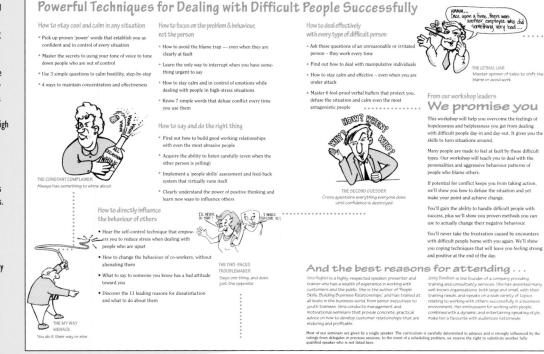

Some seminar and conference mailers have found that it pays in terms of greater response to mail their brochures as a flat and pay the extra postage. A flat is a mailing piece larger than at least one of the maximum dimensions for letter mail (height: 6⅛ inches; length: 11½ inches; thickness: ¼ inch) and/or doesn't meet aspect ratio rules (see page 42), but does not exceed any of the maximum dimensions for flat mail (height: 12 inches; length: 15 inches; thickness: ¾ inches).

"This was the first less serious approach the company had used for tough subjects. I knew the cartoons would get a lot of attention, so I wanted to control the reader's eye flow. I used the placement of the cartoons and the dotted rules to lead the eye to important copy blocks and from page to page. I used the dotted rules for their lighter look and feel than solid rules, and because they make a path rather than a border. Because a lot goes in an eight-page seminar brochure (letter on page 2, article copy on page 3, agenda on middle spread, reply form), I used a six-column underlying grid. I also made sure there was a lot of white space, because I wanted to contrast the open feeling against the intense emotion that dealing with difficult people generates."

Difficult people . . . they're a fact of life . . . but you can deal successfully with them ONCE YOU KNOW HOW!

Performance Seminars presents

Dealing Successfully with
DIFFICULT PEOPLE
a one day seminar

£89
Satisfaction Guaranteed!

THE STONE-WALLING STOPPER
All progress and good ideas come to a halt here

Cities and dates

Bristol
18th October 1996

Leeds
21st October 1996

London
25th October 1996

Want to attend, but need a different date?

Call us!

We frequently add more dates and locations.

Powerful solutions to neutralise & eliminate the negative effects of office problem people

- How to deal with the dictators, tyrants and backstabbers who spread negativity and lower morale.
- How to easily counter the 'misery' spread by the chronic complainers, fault-finders and nay-sayers.
- What to say to the put-down pros and 'my way only' types who put down every idea if it isn't their own.
- Proven techniques to deal with the connivers and people who love to snipe at you behind your back.
- Successfully deflect the criticisms and negative comments from bullies and other obnoxious types.
- Hear easy, effective tactics to neutralise the effects the 15 most common types of difficult people have on others.
- How to be cool, calm and collected in even the toughest situations.

Your day-to-day encounters with these types can be managed . . . and their effect on you and everyone else around them can be minimised. See how in this dynamic one-day workshop!

Reduce the anger, stress and conflict difficult people cause

NO ! NO ! NO !

THE NAY SAYER
NO, it won't work, NO, we can't do it and NO, we won't try it

To register, ring 0118 981 0055

Seminar Brochure
MARY PRETZER, COMPACT DESIGN
Seminar brochures focus on the "promise." And this one was a big winner. It tested against another creative approach and won by 21 percent. The seminar itself was the second biggest draw in the history of the company. The actual results are proprietary, but note that in seminar mailings, you are flying high at 0.5 percent—that's five responses per thousand pieces mailed! And this design did better than that on launch.

Most seminar brochure designs are two-color without photographs. Four-color with photographs gets tested too and works for some topics, but two-color is the workhorse. Eight-pagers currently seem to be dominating for one-day seminars. Whatever the format, seminar self-mailer design must accommodate bulleted lists of promises and benefits all over the place.

Powerful Techniques for Dealing with Difficult People Successfully

How to stay cool and calm in any situation

- Pick up proven 'power' words that establish you as confident and in control of every situation
- Master the secrets to using your tone of voice to tone down people who are out of control
- Use 3 simple questions to calm hostility, step-by-step
- 4 ways to maintain concentration and effectiveness

THE CONSTANT COMPLAINER
Always has something to whine about

How to directly influence the behaviour of others

- Hear the self-control technique that empowers you to reduce stress when dealing with people who are upset
- How to change the behaviour of co-workers, without alienating them
- What to say to someone you know has a bad attitude toward you
- Discover the 11 leading reasons for dissatisfaction and what to do about them

THE MY WAY MENACE
You do it their way or else

How to focus on the problem & behaviour, not the person

- How to avoid the blame trap — even when they are clearly at fault
- Learn the only way to interrupt when you have something urgent to say
- How to stay calm and in control of emotions while dealing with people in high-stress situations
- Know 7 simple words that defuse conflict every time you use them

How to say and do the right thing

- Find out how to build good working relationships with even the most abrasive people
- Acquire the ability to listen carefully (even when the other person is yelling)
- Implement a 'people skills' assessment and feed-back system that virtually runs itself
- Clearly understand the power of positive thinking and learn new ways to influence others

THE TWO-FACED TROUBLEMAKER
Says one thing, and does just the opposite

How to deal effectively with every type of difficult person

- Ask these questions of an unreasonable or irritated person – they work every time
- Find out how to deal with manipulative individuals
- How to stay calm and effective – even when you are under attack
- Master 6 fool-proof verbal buffers that protect you, defuse the situation and calm even the most antagonistic people

THE LETHAL LIAR
Master spinner of tales to shift the blame or avoid work

From our workshop leaders
We promise you

This workshop will help you overcome the feelings of hopelessness and helplessness you get from dealing with difficult people day-in and day-out. It gives you the skills to turn situations around.

Many people are made to feel at fault by these difficult types. Our workshop will teach you to deal with the personalities and aggressive behaviour patterns of people who blame others.

If potential for conflict keeps you from taking action, we'll show you how to defuse the situation and yet make your point and achieve change.

You'll gain the ability to handle difficult people with success, plus we'll show you proven methods you can use to actually change their negative behaviour.

You'll never take the frustration caused by encounters with difficult people home with you again. We'll show you coping techniques that will leave you feeling strong and positive at the end of the day.

THE SECOND GUESSER
Cross questions everything everyone does until confidence is destroyed

And the best reasons for attending . . .

Vera Hughes is a highly-respected speaker, presenter and trainer who has a wealth of experience in working with customers and the public. She is the author of 'People Skills, Building Business Relationships,' and has trained at all levels in the business world, from senior executives to youth trainees. Vera conducts management and motivational seminars that provide concrete, practical advice on how to develop customer relationships that are enduring and profitable.

Jenny Boreham is the founder of a company providing training and consultancy services. She has assisted many well-known organisations, both large and small, with their training needs, and speaks on a wide variety of topics relating to working with others successfully in a business environment. Her enthusiasm for working with people, combined with a dynamic and entertaining speaking style, make her a favourite with audiences nationwide.

Most of our seminars are given by a single speaker. The curriculum is carefully determined in advance and is strongly influenced by the ratings from delegates in previous sessions. In the event of a scheduling problem, we reserve the right to substitute another fully qualified speaker who is not listed here.

Magalogs

Magalogs are magazine/catalog hybrids—hence "magalog"—with lots of copy and usually quite a bit of art. They're a specialized form of self-mailer that's longer than the normal four-page self-mailer yet shorter than most catalogs. The product is featured along with magazine-style copy. The visual battle is between wanting people to read the informative sell copy, but also wanting them to move along to make a decision. People who buy via a magalog get a pretty full view of the product or service since there's plenty of room to show-case a fully developed concept and a full range of benefits. The format requires and promotes longer involvement than other types of self-mailers.

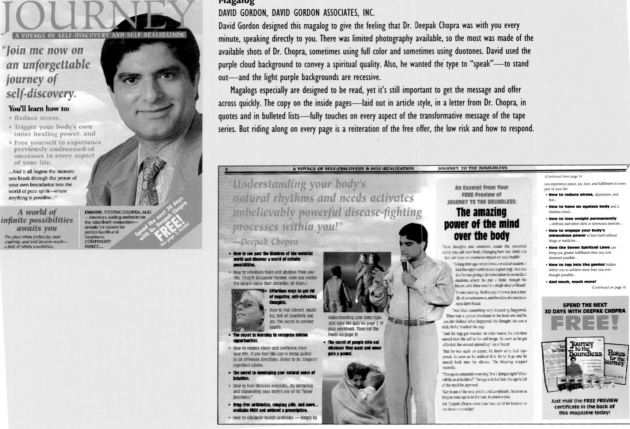

Magalog

DAVID GORDON, DAVID GORDON ASSOCIATES, INC.

David Gordon designed this magalog to give the feeling that Dr. Deepak Chopra was with you every minute, speaking directly to you. There was limited photography available, so the most was made of the available shots of Dr. Chopra, sometimes using full color and sometimes using duotones. David used the purple cloud background to convey a spiritual quality. Also, he wanted the type to "speak"—to stand out—and the light purple backgrounds are recessive.

Magalogs especially are designed to be read, yet it's still important to get the message and offer across quickly. The copy on the inside pages—laid out in article style, in a letter from Dr. Chopra, in quotes and in bulleted lists—fully touches on every aspect of the transformative message of the tape series. But riding along on every page is a reiteration of the free offer, the low risk and how to respond.

Catalogs

Catalogs are the only type of direct mail that can get people to buy something they didn't already think they had some interest in. They may open the catalog for one item and end up getting something they had no intention of buying just a few minutes earlier. Catalogs have no passalong value. They are the only kind of direct mail that people keep, or even hoard.

Backhill Catalog

MARK JAGER, CREATIVE DIRECTOR; MARK SYLVESTER, ART DIRECTOR. MARK SYLVESTER, ANDREW SZURLEY, JEFF ROONEY AND ED WILBUR, DESIGNERS. JAGER DI PAOLA KEMP DESIGN
Backhill learned it was a waste of time to market to parents. So this catalog was "kid directed," designed to directly appeal to boys and girls six to fourteen years old. And it's the kids who make the purchase decision. (The market is about 60 percent boys and 40 percent girls.) The catalog does not follow classic direct mail rules for catalogs—the best products are not on the center spread and it takes two pages before the reader gets to the products. There's a lot of information. And that's deliberate. The kids interact with it like a booklet with an extra bonus—they get to order great stuff from it. The catalog is super effective at selling expensive outerwear, the products that are unique. They're actually easier to sell than a T-shirt via this catalog. Orders come in later from this vehicle. It stays in the kids' hands for awhile, so the catalog was designed to be durable with good cover stock.

TECHNICAL SNOWBOARD CLOTHES FOR KIDS

BACKHILL

fit + function all orders shipped FedEx Second Day
guaranteed 1-800-BACKHILL
222.5445

HOOD PULLOVER

Mt. Hood is the home of a glacier, a place where there is ALWAYS snow. It's so high, sometimes you can ollie a cloud. The Hood Pullover is cloud-busting protection that seals with an easy zip, and a hood that's always there when you need it. On the warm days flip the top down and unzip.

Important stuff for snowboarders:
• WB2000 nylon fabric. • Core Insulation. • Mammoth fleece around your body. • 1/2 zipper with Velcro storm flap. • Adjustable wrist cuffs • Soft chin flap. • Full-time Face-Space® Hood. • Glove loops. • Reflector tape. • Venting pit zips. • Stash draw cord at hem. • Sit-Without-Soak® Toughstuff butt.

Important stuff for parents:
• Waterproof/breathable WB2000 nylon fabric. • Core Insulation: Mammoth fleece plus 80g Thermolite® insulation around the body, 80g in the sleeves. • Toughstuff drop tail butt panel with 100% waterproof PVC Sit-Without-Soak® lining.

COLORS:
Navy/Yellow Pool Blue/Navy Red/Khaki
sizes: s m l xl
Item #: 7104 Imported $115.00

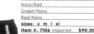

KICKER PANTS

Soggy pants can put the stinkbug in any air, and turn your butt into a traveling Itchy and Scratchy Show. Staying dry is important. Even the best riders have to sit down to buckle in or ride the chair lift–if you don't have the right pants, you're going to sponge up some of that water. The Kicker Pants will keep you dry all day, whether you stick it or crash.

Important stuff for snowboarders:
• WB2000 nylon fabric. • Core Insulation: Extra warmth for your knees and butt. • D-ring to attach lift ticket. • Interior gaiters. • Reflector tape. • Toughstuff butt panel and cuff protection. • Stretchy waist with cinch lock.

Important stuff for parents:
• Waterproof/breathable WB2000 nylon fabric. • Core Insulation: 150g Thermolite® insulation on butt and knees, 80g everywhere else. • Toughstuff butt panel and cuff protection for durability and warmth.

COLORS:
Navy/Red
Green/Navy
Red/Navy
sizes: s m l xl
Item #: 7106 Imported $90.00

Red/Khaki

Navy/Yellow

Pool Blue/Navy

OUTER LAYER

FIT KIT

SIZE:	S	M		
AGE (yrs.)	5+6	7+8	9+10	11+12
Height (in.)	44-48	49-53	54-58	59-63
Weight (lbs.)	46-49	50-59	60-73	74-100
Chest (in.)	24-26	26-28	28-32	32-34
Waist (in.)	22	23	24-25	26-28
Hip (in.)	25-26	27-29	30-32	33-35

TG

B

fit + function all orders shipped FedEx Second Day
guaranteed 1-800-BACKHILL
222.5445

Navy/Red

Green/Navy

Gaiters keep snow
out of your boots.

Red/Navy

MG

TG

9

The Envelope Mailing: The Workhorse of Direct Mail

The envelope mailing is the workhorse of direct mail design formats. Its basic elements are an outer envelope, a letter, a response device, a brochure and a return envelope. Think about all the people who sort their mail over their wastebasket. What would make envelope mailings attract them more than other direct mail formats like the quick-and-easy-to-read self-mailer, the post-card or the highly pictorial magalog?

Perhaps envelope mailings work because people associate them with pleasant experiences like personal letters. They like opening the envelope, being entertained. Rifling through the pieces, skimming the response device, even seeing if their names are spelled correctly somehow entices people. People like getting mail, and envelope mailings connote personal communication.

Plus, for many types of offers, the envelope mailing is really needed. To make an informed decision, people need the relatively large amount of information and the review of benefits that can be effectively conveyed in the envelope format. They need the reassurance offered by the letter and the brochure.

That's not to say that other formats don't work—they obviously do for various types of mailings. But, at the end of the day, direct mail design is always driven by the numbers—response and profitability. And obviously, because we see envelope mailings so often, for many mailers they do the job the best.

Two Kinds of Envelope Mailings

There are two kinds of envelope mailings—the kind that looks like junk mail and the kind that looks like it's personal or official correspondence (maybe it even looks like there's a check inside).

The envelope that looks like junk mail makes no pretenses. We look at it and know what it is. The second kind might get the envelope opened by fooling the reader, but once opened it can actually cause irritation, annoyance or an even stronger negative emotion and speed the mailing's trip to the wastebasket.

Remember, once people open direct mail that looks like advertising mail, they have agreed to be sold to. They've let you get your foot in the door.

What to Do With All That Copy

Copy is king in direct mail, and envelope packages—with the letter and all the other pieces—usually have the most copy of all but the magalog and bookalog.

Your job as a designer is to frame the offer and highlight the benefits, plus visually capture the concept underlying the copywriter's pitch. You have to get

Saveur

DESIGN: HEIKKI RATALAHTI, JAYME, RATALAHTI, INC.
COPY: BILL JAYME, JAYME, RATALAHTI, INC.

"The very premise of *Saveur*—real food produced in real places by real people—pretty much rules out stock photography. With their flawless skin, matching teeth, symmetrical figures and clothing that has never been worn before, models are hardly real people. Real people have freckles, loopy smiles, lumpy figures and bacon stains on their sweaters.

"*Saveur* takes its inspiration from Europe's leading food magazine, the French publication *Saveurs* ('tastes'). The U.S. version signals a return to the traditional dishes enjoyed by an earlier America that had no worries about calories, salt, sugar, cholesterol, additives, preservatives, fat. Its subject is genuine food as prepared by people all over the world. The recipes it serves up are authentic ones undiluted by substitutions or 'improvements.'

"The problem in designing the mailing package that launched *Saveur* in America was how to convey this immediately on the outer envelope. Words were out. Potential advertisers might be scared off. So might potential subscribers who are fixated on their diets.

"Then to my delight, I found in French *Saveurs* precisely the photograph I was looking for—an old woman seated outside her cottage preparing her garden vegetables. The minute the reader takes the package from her mailbox, she knows from the photograph where the magazine is coming from. The result is that this *Saveur* poster girl has successfully attracted virtually all of the magazine's early and sizable up-market circulation."

> "**A**n art director/designer must recognize the importance of reading the copy thoroughly (sounds obvious, but trust me, it doesn't always happen that way), then examine it, take it apart and reconstruct it if need be to make it work better.
>
> Never fear suggesting changes in text if those changes will make the package better. I recall several times in my career coming across a phrase or a sentence buried deep in the copy, which to my mind made a far better headline or envelope phrase than the one(s) being used. And I got them changed.
>
> Remember at all times that the designer is also—in his way—a copywriter and a marketing person. You can't separate them."
>
> — RICHARD B. BROWNER
>
> Richard Browner, Inc.

all the elements to work together conceptually, while designing each element to be autonomous. Since you do not know which element the reader will go to first, each individual element must contain key benefits, focus on the offer and make the sale all on its own, as well as work in concert with all the other elements. And remember, your readers only give you eighteen seconds on average to make the sale.

Where the Emphasis Belongs in Direct Mail Design

Most direct mail copy fits into one of four categories:

1. benefits

2. description

3. support copy

4. sweeteners and facilitators.

Each type of copy convinces readers that they can really believe in the offer, that they can trust the business or person making it, and that they won't make a mistake by responding.

Benefits are the most important copy in your package and should not be confused with features. Features are attributes that belong to the product or service, while benefits are what make those attributes useful or attractive to the

reader. A benefit shows how the product or service will improve the potential responder's life.

Descriptive copy replaces personal examination—the "tire kicking."

Support copy speaks to the validity of the claimed benefits. Essentially, this copy answers the reader's potential objections. Support copy includes:

- data/statistics/field research—your own or someone else's, although facts and figures from someone else will be perceived as more impartial and therefore more credible.

- examples like case studies or histories. Case studies, usually written in the third person, tell how the product or service solved problems, provided solutions, saved money or made money for a customer.

- testimonials—first-person, unpaid recommendations from customers, donors or members—which are very effective with intangible products like self-improvement programs, insurance or charities. Paid endorsements, also a type of support copy, are the least believable to the reader.

Sweeteners "sweeten" the offer by giving the reader more reasons to take it. They fall into two categories: incentives and choices. Incentives can ensure readers that they get something, even if they don't order, subscribe or sign up—for example, "a free gift, yours to keep even if you return the product." This category also includes bonus items, such as "buy your computer now and get a memory upgrade free." Choices range from variety (model or color) to quantity (one- or three-year membership, individual or family) to accessories (supplementary service, report, parts, add-ons). Choices can be a problem if people have to think about them too hard. Only offer choices that make it more likely someone will respond.

Facilitators make responding easier. They include anxiety relievers (e.g. guarantees), ways to make responding easier (e.g. toll-free numbers), and ways to make paying easier (e.g. "Bill me later." "Send No Money Now.").

Design That Sells

Great direct mail design emphasizes the benefits, the descriptive copy, the support copy, the sweeteners, the facilitators and the incentives and choices, so that wherever the reader looks there's another advantage to ordering, joining, signing up, responding today!

The Outside Envelope aka "The Outer"

or

What's in It for ME?

The first job of a direct mail designer is to get the outer envelope opened. You've got seven seconds--the time it takes the average person to look at and open or discard your package. It helps to understand the sequence in which this average person digests the copy and graphics on the envelope.

First, he looks at his name in the address area.

Then, he looks at any teaser copy, graphics and involvement devices.

Third, he looks at the return address area.

Fourth, he looks at the postage area.

Finally, he turns the envelope over to look at other graphics or copy and/or to open.

What stops the eye and the brain? How do you kick start the response reaction so that by the time the reader opens the envelope and touches the next element in the package he is already halfway to making a "yes" decision?

Capturing the Concept

The best outer envelopes capture the underlying concept of the mailing and what the creative team thinks drives the decision to respond. That might call for brilliant four-color photography. Or it might call for brilliant simplicity—a plain white envelope and a few words such as "The favor of a reply is requested" in a script or italic font. Or how about the lowly kraft envelope? It's a powerful direct mail weapon. It conveys the impression of "official business," and to some recipients, it connotes a deal.

Plain white envelopes, kraft envelopes, four-color envelopes—what you use totally depends on how you think the prospective customer is thinking, what's going to get the envelope opened and what's going to get the response you want.

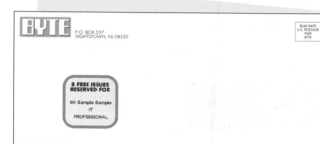

DAVID WISE, WISE CREATIVE SERVICES, LTD.
Here are three examples from David Wise that illustrate outer envelope design strategy. He let copywriter Ken Schneider's straightforward teaser speak for itself in the 6" x 9" envelope and placed a sunny "FREE" in the die cut. The *BYTE* and "Keep It Beating" packages were done with copywriter Josh Manheimer. The *BYTE* envelope is directed to information technology professionals and looks more businesslike. Using a white envelope in standard sizes saves money, but for some offers, four-color is absolutely required, like the luscious "Keep It Beating" package, which was selling a low-fat cookbook.

Open this envelope in full sun or shade and water contents regularly...

FREE

EXCLUSIVE INVITATION – FREE SEEDS INSIDE

"**W**ould I lead with a picture of an outrageous chocolate dessert to dieters and low-fat cookbook buyers? You bet! Because self-deprivation is not a comfort zone for most customers. Their comfort zone, however, would be indulging in their favorite foods without a disastrous health effect. So after all, the decisions I make are common sense. That is how winning direct response promotions are designed."

— D A V I D W I S E

Wise Creative, Ltd.

What Are You Selling? And to Whom?

In general, envelopes for subscriptions, book offers, financial advice newsletters and some technical products (software, software upgrades, add-ons) announce they are "advertising mail." You see stronger teaser copy, bolder graphics, even four-color photography and coated stock. It's the approach that works for single product offers, offers that only take one person to decide to respond or where cost is something one person in a business can pay for immediately or get approval for pretty easily.

Lead-generation mailings for higher-end products to executives and upper management at a business address are more often designed to look like personal business mail—a tasteful #10 business envelope with either no teaser copy or very low-key teaser copy like "Personal and Confidential" or "To Be Opened by Addressee Only."

Fund-raising mailing envelopes also tend to be designed simply, to look low-cost. You don't want to look like you're wasting money on fancy mailings.

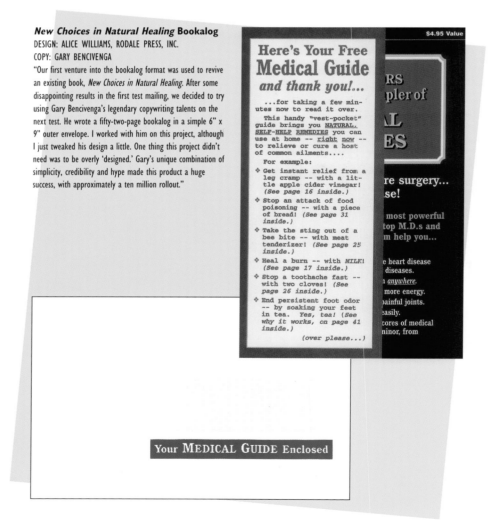

New Choices in Natural Healing Bookalog
DESIGN: ALICE WILLIAMS, RODALE PRESS, INC.
COPY: GARY BENCIVENGA
"Our first venture into the bookalog format was used to revive an existing book, New Choices in Natural Healing. After some disappointing results in the first test mailing, we decided to try using Gary Bencivenga's legendary copywriting talents on the next test. He wrote a fifty-two-page bookalog in a simple 6" x 9" outer envelope. I worked with him on this project, although I just tweaked his design a little. One thing this project didn't need was to be overly 'designed.' Gary's unique combination of simplicity, credibility and hype made this product a huge success, with approximately a ten million rollout."

$4.95 Value

Here's Your Free Medical Guide and thank you!...

...for taking a few minutes now to read it over.

This handy "vest-pocket" guide brings you NATURAL, SELF-HELP REMEDIES you can use at home -- right now -- to relieve or cure a host of common ailments....

For example:

❖ Get instant relief from a leg cramp -- with a little apple cider vinegar! (See page 16 inside.)

❖ Stop an attack of food poisoning -- with a piece of bread! (See page 31 inside.)

❖ Take the sting out of a bee bite -- with meat tenderizer! (See page 25 inside.)

❖ Heal a burn -- with MILK! (See page 17 inside.)

❖ Stop a toothache fast -- with two cloves! (See page 26 inside.)

❖ End persistent foot odor -- by soaking your feet in tea. Yes, tea! (See why it works, on page 41 inside.)

(over please...)

Your MEDICAL GUIDE Enclosed

Vogue

DESIGN: JYL FERRIS, FERRIS & COMPANY
COPY: RUTH K. SHELDON

Filmy, diaphanous fashion was hot, so why not use a slimmer-than-standard, see-through envelope? It's provocative and seductive, and it stands out in the mail. The strong color on the inside pieces along with the classic typography focus the reader on the offer, while the see-through envelope pulls the reader inside.

Garden Answers

ALICE WILLIAMS, RODALE PRESS, INC.

The bold, woodcut-style illustrations by illustrator Brian Swisher work to give this envelope a warm, welcoming, folksy feel. Williams says that this package was very cost-efficient because of the simple 6" x 9" format, and because she only used one color separation in the whole thing (to shoot the book the package promoted). All the illustrations were flat tint breaks.

Working Within the Rules

Postal regulations dictate a whole lot of what you can do with an outer envelope and what you have to design around. While you can get almost anything delivered if you're willing to pay the price, paying attention to the postal service's rules can save your client a lot of money. And for large-volume mailers, where postage is the biggest marketing expense, you can't ignore the postal rules that earn discounts.

Automation mail (First-Class or Standard) gets the largest postal discounts. Automation mail is mail that is machinable and readable. That means it's the right size and material for fast handling by USPS equipment, that the address is prebarcoded, and that the address area and bar code can be read by USPS equipment.

Weighty Matters

If your client is mailing at First-Class, it pays to keep the package weight less than one ounce. Pieces mailing at Standard Mail A Regular Rates may weigh up to 3.3 ounces.

Letter-Sized Envelopes

	Minimum	Maximum
Height	3½"	6⅛"
Length	5"	11½"
Thickness	.009"	¼"

Flats are unwrapped, paper-wrapped, sleeve-wrapped or envelope mailings bigger than the maximum letter size (6⅛" × 11½") in one or both dimensions, but don't exceed the dimensions in the table below. Flats can be any proportion.

Flat-Sized Mail

	Minimum	Maximum
Height	6"	12"
Length		
6-7½" high	5"	15"
Over 7½" high	6"	15"
Thickness	.009"	¾"

Mailpieces that fall within these dimensions are eligible to qualify for automation rates. The postage rates for flats are higher than those for letter-sized mail. So if you choose to use flats for your direct mail designs, you should be confident they will pay for themselves in extra response.

The Flat Mail Machinability Tester

The post office uses the Flat Mail Machinability Tester to determine if a flat meets the machinability requirements to qualify for automation rates. The tester measures if the flat is flexible enough to go around turns in the flat sorting machine. It also measures if the piece is stiff enough to be handled without catching or jamming.

No rigid or odd-shaped articles—e.g., freemiums like pens or three-dimensional samples—may be included because they might jam equipment. But depending on placement, credit and membership cards (especially those spot glued onto a backing so they stay in place) or coins can get USPS approval.

The USPS Web site at www.usps.gov has the most current information, and there are local Postal Business Centers where you can get detailed information.

The Basics on Size for Letters and Flats

Direct mail designs are likely to fall into one of two USPS categories—letters or flats. Letter-sized mail is rectangular and falls within the guidelines in the table on page 42. To be automatable, the length of the letter divided by the height (the aspect ratio) must fall between 1.3 and 2.5.

Tip

The United States Postal Service (USPS) reports that 83 percent of consumers say they will open an envelope that looks like it has a free sample inside; only 18 percent say they will open an envelope that says "Sweepstakes."

Envelopes We Know and Love

Using standard-sized envelopes saves time and money in direct mail efforts. And to justify using envelope sizes that mean a greater postage cost for the client, you really have to have a strong conviction that your solution is going to generate much better response.

Why the Ubiquitous Window Envelope?

Direct mailers use window envelopes so the recipient's name and address can be printed on the reply form that shows through the window. There are two benefits to this way of addressing:

1. It's a rule in the industry to make responding easy—making a person go through writing his or her name and address is an impediment to easy response. So you print the name and address on the reply form. Any other solution for getting the name on the reply form costs more.

2. You eliminate a processing step. The envelope does not have to be addressed separately.

 Standard window envelopes place the window on the left. Standard window size is 1⅛" x 4½". If you want the window on the right or a different size, build time into your mailing plan for envelope conversion. (Instead of being able to take a standard envelope from inventory, the envelope supplier may have to manufacture [convert] the envelope.) The window die cut itself needs to be at least ½ inch from the bottom of the envelope and ⅞ inch from the closest edge.

 You need a minimum of ⅛ inch between the address and the edges of the window on the right and left. Bar codes are printed above or below the address. When you design the reply form, be sure there will be at least .04 inch between the top or bottom of the bar code and the window edge. Leaving more white space between the edges of the window and the address and bar code is a good idea—use ¼ inch or more to be safe.

Do the Tap Test

Your mailing has to pass the tap test. That means if the USPS taps one envelope in the mailing and the address shifts out of the window area, the whole mailing can fail to qualify for automation. So be sure to design the reply form so that the address area stays put in the window.

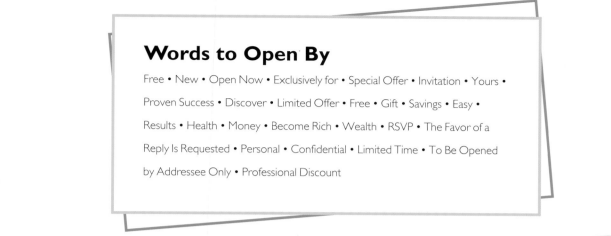

Words to Open By

Free • New • Open Now • Exclusively for • Special Offer • Invitation • Yours •

Proven Success • Discover • Limited Offer • Free • Gift • Savings • Easy •

Results • Health • Money • Become Rich • Wealth • RSVP • The Favor of a

Reply Is Requested • Personal • Confidential • Limited Time • To Be Opened

by Addressee Only • Professional Discount

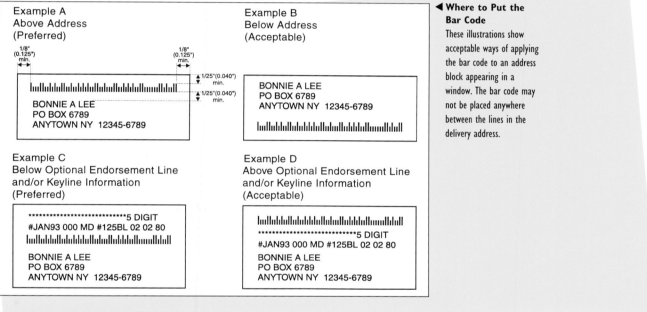

Example A
Above Address
(Preferred)

BONNIE A LEE
PO BOX 6789
ANYTOWN NY 12345-6789

Example B
Below Address
(Acceptable)

BONNIE A LEE
PO BOX 6789
ANYTOWN NY 12345-6789

Example C
Below Optional Endorsement Line
and/or Keyline Information
(Preferred)

****************************5 DIGIT
#JAN93 000 MD #125BL 02 02 80

BONNIE A LEE
PO BOX 6789
ANYTOWN NY 12345-6789

Example D
Above Optional Endorsement Line
and/or Keyline Information
(Acceptable)

****************************5 DIGIT
#JAN93 000 MD #125BL 02 02 80
BONNIE A LEE
PO BOX 6789
ANYTOWN NY 12345-6789

◀ **Where to Put the**
Bar Code
These illustrations show
acceptable ways of applying
the bar code to an address
block appearing in a
window. The bar code may
not be placed anywhere
between the lines in the
delivery address.

Bar Code/
Window Clearance
The post office likes white space. This
diagram shows the minimum amount
of white space required between the
bar code/address and the edges of the
window—.04 inch on top or bottom,
and ⅛-inch on each side. (Just to be
safe, it's a good idea to allow ¼ inch
or more all around.) Make sure the
address stays within these guidelines
even when you tap the envelope on
any side. To avoid postal nightmares,
design your package so the reply card
(or whichever piece carries the
recipient's address) can't shift around
in the envelope.

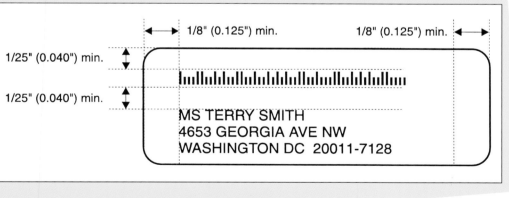

MS TERRY SMITH
4653 GEORGIA AVE NW
WASHINGTON DC 20011-7128

A NO-NO: Dark Colors Behind Address

Don't design pieces so addresses and bar codes are printed on dark envelopes or dark backgrounds. The post office's optical character (OCR) and bar code readers may not be able to read it. Always use white or light backgrounds. If you're unsure of whether your design will work, take a comp to the post office for a definitive ruling.

Postage

Stamps give recipients the idea that the mail was handled by a real person who put the stamp on lovingly. However, for many bulk mailers, putting stamps on is just too costly.

Metered mail connotes business-to-business mail to most people. Metering is also more costly than a printed indicia because each envelope must be separately metered—an additional processing step.

Printed indicias (the permit imprint in the upper left-hand corner that indicates postage class and permit holder) are easiest and cheapest. Indicias do not have to be placed in rectangular boxes, but instead can be designed to have their own look or to look like metered mail. Many designers choose to design the printed permit to be very simple and as unnoticeable as possible. After all, who wants the indicia noticed?

Indicias

Printed indicias can be just a plain box with the rate information (top example). The recipient glances at it and knows this is bulk mail. When designed to look like metered mail (middle example), the implication is that the mail comes from a business and the postage was applied individually. Other ways to handle the indicia are to actually design it to be more consistent with the look and feel of the mailing (bottom example). There are no "rules" on this subject, except the USPS's that say the class of mail and/or the name of the permit holder or place of mail entry must be included.

What You Can Put on the Envelope Where

Teaser copy, die cuts, logos and other graphics are not permitted in the OCR area directly to the right and left of the delivery address lines on the envelope. For closed-face envelopes that are not prebarcoded, keep graphics and copy out of the area to the right and left of the delivery lines (street address and city, state and zip). For window envelopes, it's a good idea to leave more than the minimums between the window edge and any copy or graphic elements. As a rule of thumb, leave at least ½ inch of white space all around where the address block will print. Then the envelope itself can have pretty much anything you want on it. Look at the direct mail you get for examples of what will fly. If in doubt, take a comp to the post office facility where the bulk mailing will drop and get a ruling.

Mailpiece Clear Zones and Freespace

If you want to get the best postal rates (which means designing packages that qualify for automation discounts), make sure the front of your envelope meets the USPS guidelines illustrated here. If ever in doubt, ask the direct mail specialist at the post office where you're mailing.

Place the address anywhere in the OCR Read Area shown. If the mailing is not prebarcoded, the post office will apply the bar code in the lower right, so leave that area free of design and copy.

The post office's OCR (optical character reading) equipment reads the street address and the city/state/zip line; the barcode reader reads the bar code, if the mail is prebarcoded. The key is to keep the areas immediately to the right and left of these lines clear of printing, die cuts, etc. The USPS says you can put that stuff in the OCR Read Area as long as it is above the street address line. For window envelopes, keep the area immediately surrounding the address block free of copy and design elements—½ inch of white space to right and left is a good minimum.

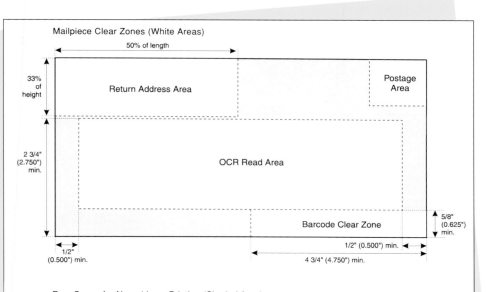

Mailpiece Clear Zones (White Areas)

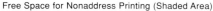

Free Space for Nonaddress Printing (Shaded Area)

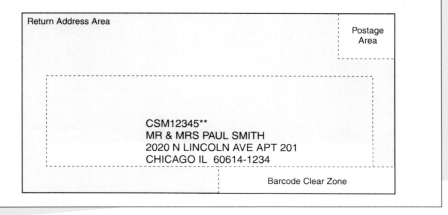

Not to scale

Involvement Devices Near the Name

Involvement devices, things that get the recipient involved in doing something, generally increase response. The most commonly used involvement device is a circular die cut on the envelope with a brightly colored—typically red—peel-off (or faux peel-off) sticker peeking out. Nine times out of ten the sticker touts what's FREE inside. (The die cut does not have to be covered with a clear material like polystyrene.)

A cheaper way to get almost the same effect is to print just a brightly colored circle on the envelope. "Almost" is the operative word here. You can't get the same seduction as you do with the die cut. The die cut piques more curiosity, is more provocative.

Blockbuster Mailing for *Writer's Digest* DESIGN: DAVID WISE, WISE CREATIVE SERVICES, LTD. COPY: JOSH MANHEIMER This package for *Writer's Digest* remained the control for many years. Look at some of the elements that make the outer work: typewriter-looking type for writers, an indicia designed to look like metered postage, teaser copy with eye flow pointing toward the name in the window and vice versa, a big "FREE BONUS GIFT" die-cut involver. On the reverse side, the free gift is touted with a big "PLUS." Makes you wonder—"Is that the bonus gift? Or do I get two gifts?" Guess you'll have to open it to find out.

And on the Flip Side

The more out-and-out promotional the mailing is, the more it makes sense to have teaser copy and/or graphics on the reverse side where the person sees it at the moment of opening. The idea, though, is to keep the motion going toward opening. Nothing should stop the person or cause irritation or confusion. What she sees should be another push towards opening the package.

Another way to look at the function of teaser copy or graphics on the unaddressed side of an envelope is that it should sell all by itself. (Remember, you can't guarantee the recipient will see the front side first!) Ideally, whatever is on the reverse side can motivate opening all on its own.

In the Beginning

What will get it opened? The outer may be the biggest conceptual challenge of the mailing. It's where you find out if your analysis of what makes the audience tick is on target. Plus you have to play by the USPS rules. It's the tough stuff that makes direct mail so challenging. You gotta love it!

Production Tips From the Lettershop

One of the most frequent problems lettershops run into is that the outer envelope specified by the designer isn't large enough to accommodate all the insert material. In general, the envelope should be at least ½ inch longer and ¼ inch taller than any insert. Some lettershops recommend ⅜ inch all around. If the contents are especially bulky, that may not be enough. Here are some tips from the lettershop to avoid possible problems:

- Create an insertion comp—put all the pieces (using the actual papers you'll be using) in order in the envelope and have the lettershop take a look at it.

- Check with the lettershop that the design of the envelope is okay for insertion. The throats on some envelopes won't work.

- When you're designing a multifolded brochure, the insertion equipment requires a closed-edge for the "grippers" to grab and drop each insert into the envelope. That's why your letter needs to be C-folded with the salutation facing out.

- When you send the job to the lettershop, send a comp of how the pieces are to be placed in the mailing. You want the letter to face the back of the envelope so it's the first thing the reader sees when opening. The address side of the response device needs to face the window. The brochure and other inserts should follow the letter.

- And last but not least, be sure your Business Reply Envelope is smaller than your outer envelope.

The Direct Mail Letter

or

"Dear Reader"

How to Turn Eye Flow Into Cash Flow

Ask any direct mail pro and they'll tell you the letter is the heart and soul of the direct mail package. And it's a unique design challenge. It must retain attributes of personal correspondence, yet function as a highly efficient selling machine.

The beauty of the letter is that it is perceived as person-to-person communication. The letter captures one of the key advantages of direct mail more than any other element in the package--the voice of one person speaking to another person, even though the minute the reader looks at it, she knows it's not from a friend, business acquaintance or her mother.

As a rule of thumb, a mailing with a letter will perform better than a mailing without one. Yet, paradoxically, almost no one reads every word of a direct mail letter.

How Do People Read Direct Mail Letters?

First, people scan the letter from top to bottom, looking for graphically emphasized words or phrases. Every time they find one they stop for about two-tenths of a second. Called fixations, these eye-stops are on headlines, subheads, characters in uppercase, underlining, bold type and phrases set off by ellipses. This skimming pattern is followed whether the letter is one page or several pages long.

Next the reader looks at the signature area and glances at the PS before returning to the top of the first page.

All this takes just seconds.

There is a little difference if the letter is personalized—that is, if the salutation uses the recipient's name instead of a generic greeting like "Dear Colleague." In that case, the reader will first look at his or her name and then check the signature at the bottom of the letter. Then the reader resumes the normal scanning pattern as described above.

Photos or illustrations in the letter tend to continually draw the eye instead of letting it move naturally through the text of the letter to the highlighted areas.

If you use photos or illustrations, take advantage of the average person's eye-flow pattern. On the first page, place the photo or illustration at the top of the page, followed by the headline.

Photos and illustrations used throughout the body of the letter should always be secondary to copy and constantly push the reader back into the text. The "directionality" of the subject matter of the art should point to important copy.

"Sight-Bite" Letter Layout

To make a direct mail letter effective, lay it out in "sight bites" of graphically emphasized copy. A sight bite might be thought of as a portion of the visual field that's easy for the eye to find in a sweep over the layout. Your goal is to make an emotional connection with the reader and to make the compelling selling points stand out.

In the best direct mail letters, paragraphs are very short—sometimes only one sentence. Important text is highlighted with ellipses, subheads in bold,

Eye-Stops: Hot Spots on the Letter

headline above salutation

signature area

PS

first few paragraphs

highlighted copy

indents, bulleted lists, underlining, all caps, etc. The letter breaks at the end of the page in the middle of a compelling sentence to get the reader to turn the page. Although it may seem like overkill to the uninitiated, you might even add instructions to the reader—even an arrow—to get him to turn the page.

To make a direct mail solicitation more effective, lay it out to make it easy to read and skim. The letter will have more selling power if paragraphs are short and it uses bulleted lists or other techniques that put some "air" in the copy.

If you work with professional direct mail copywriters, you'll find they will more or less lay out the letter just as they want it to flow. Some are very insistent that you do not change the way their copy appears in the letter.

Sight-Bite Techniques

short paragraphs—six or
　　seven lines max

subheads in bold and/or color

bulleted lists

indented copy blocks

underlining important points

graphic emphasis devices—
　　ellipses, underlining, italics,
　　indented text, etc.

messages in the margin that
　　look like handwriting

***Home Garden* Letter**
NANCY DAVIS,
MEREDITH CORPORATION
Using photography in a letter immediately telegraphs that it is an advertising message, not one-to-one correspondence. So you want to be sure that photography moves readers toward response, rather than distracting them from the words. The beautiful flowers here tap into the home gardener's desire to surround herself with a lovely garden. The direction of the photographic images is toward the copy, framing the message with a decorative border that supports the words.

New! *From the publishers of Better Homes and Gardens® Magazine!*

HOME GARDEN.
MAGAZINE

Finally! A brand-new magazine for the kind of gardener you want to be. Confident. Successful. And ready to try new things.

Now there's HOME GARDEN, the one garden magazine that guarantees you the most satisfaction, the most beauty, the most success — with the least frustration.

A big, beautiful Premier Issue is reserved in your name. May we send it to you?

```
Dear fellow gardener,

    I wish you could have been there last weekend when I
came home from the garden center ...

    I'd lost control.

    I bought more than I needed!  More than five
gardeners could ever manage in a weekend!  And, to be
honest, I really overspent.

    It's happened before.  I want all the plants I see —
and every box or bag of anything to make them grow.
I just go nuts.

    But the moment of truth comes when I get home and
don't know where to start.  I'm overwhelmed.  WHAT?
WHERE?  HOW?  WHEN?

    If you, like me, can't get enough of gardening, but
could also use some straightforward answers before you
fly into action — take heart!

    Now there's a faster, easier, more satisfying way to
guarantee your gardening success than you ever imagined ...
        Welcome to new HOME GARDEN Magazine!

    Unlike any other gardening magazine, new HOME GARDEN
goes beyond showing you beautiful gardens.  It also shows
you how to make them happen.

    Nowhere else will you find such inspiration with so
```

Headlines: Big or Small or None

Should the direct mail letter have a headline? Yes, 90 percent of the time in some way, shape or form. One of the only times the answer is "no" is when you're trying to imitate a more formal business letter. Even then, it's possible to use a Re: or Subj: line as a headline.

Whether you use Re: lines in the letter's text font or use big type that takes up half the page, headlines are a powerful hook. Their job is to seize the reader and reel him in. They can hit the reader quickly with the strongest benefits. They can tell the reader "What's in it for me!"—either explicitly or implicitly. Or they can tease and promise at the same time.

One day years ago my writing professor handed back a story I had written, shook her head gravely, and said, "This is so bad it makes me want to quit teaching."

You can imagine what that did to my day.

And yet, this year I will make more than $125,000.00 writing in my spare time at home.

You can too.

With a little help from...

Send no money now — we'll bill you later!

NOW AT A PRICE SO LOW —
IT'S LIKE GETTING FIVE ISSUES
FREE!

Dear Friend,

If somewhere deep inside, you'd like to stay home and write a blockbuster...

If you'd like to turn your life's experiences: your sense of humor, your pain, your love affair, your fight with the landlord, your fantasies, your unique vision of the world...

...into filmscripts, plays, suspense novels, romance fiction, magazine articles...that pay...

If you'd like to sit face to face with today's top mystery writers, novelists, poets, screenwriters, playwrights, reporters...and learn their secrets for success...

...then read on.

Writer's Digest
DESIGN: DAVID WISE, WISE CREATIVE SERVICES, LTD. COPY: JOSH MANHEIMER Headline hierarchy at work. The size and color of each succeeding headline emphasizes the selling concept, leading the reader headline by headline into the letter. This letter accompanied the "BLOCKBUSTER!" outer shown on page 48.

Who Decides on Headline Design?

Well, just like any other direct mail project, it's the designer... or the writer... or the copywriter and the designer. Some direct mail copywriters just hand over the package. Some dictate exactly what they want.

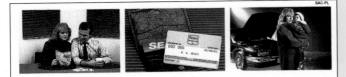

SAC-PL

Take a moment for this little quiz.
Check off the incidents that have
happened to you or someone you know?

[] Your car breaks down and needs to be towed to a service station

[] A snow storm strands you away from home overnight

[] Your car won't start because of a dead battery

[] You've got a flat tire and you're dressed in your Sunday best

[] Your car is locked and you left the keys in the ignition

[] An accident disables your car far away from home

[] Your car runs out of gas and you're miles from a gas station

[] Your car is badly stuck in snow, mud or sand

If you checked any of the above, please read on.

Dear Sears Cardholder,

If you're like me and most other Canadian drivers, you've run into most of the above problems at least once. And some probably more often than just once. They can be very expensive.

Now, for only pennies a day, you can protect yourself from the financial frustration of expensive but inevitable situations like these. For just $3.50 a month, you can join the Sears Auto Club and not have to worry about those unavoidable emergency expenses.

You certainly can't prevent these unexpected events from happening. But you can make sure you don't suffer financially when they do. You *can* give yourself peace of mind.

Towing, battery boosts, flat tire changes, unplanned hotel and food expenses, and many more. Unforeseen expenses annoy us and can set back the most careful financial planning. Join the Sears Auto Club and when the unexpected happens, we're there to help you out.

Sears Auto Club Letter
DESIGN AND COPY: RON MARSHAK,
RON MARSHAK DIRECT MARKETING
This letter was part of an envelope mailing that won with 2.11 percent response in a test, ousting the previous control package that got .67 percent. While the success of the letter can't be attributed to format and design alone, it does follow direct mail "rules" for success. Short paragraphs. Copy highlighted with underlining, dashes, ellipses, indented paragraphs. And lots of white space.

Here are just some of the ways you're protected
when you're a member of the Sears Auto Club

First of all you'll have the security of one of *the most comprehensive emergency road protection programs* available. You'll find help in just about any situation imaginable.

• *Towing:* If you have any kind of breakdown, just choose the service provider you like and away you go. You'll be reimbursed up to $50 per tow and we'll cover you up to 5 times a year.

• *Battery Boost:* Not many Canadians manage to get through a winter without needing one. And if your car won't start after the boost, we'll still pay for the tow.

• *Flat Tire:* They happen to everyone, but as a Sears Auto Club member, at least you won't have to worry about the expense of getting it changed.

• *Keys Locked In Car:* An easy mistake, but as a club member, you won't have to pay the consequences. We'll send you up to $35 to cover the cost of the locksmith.

• *Run Out of Gas:* It doesn't happen too often, but isn't it nice to know we'll pay up to $25 to have gas delivered to your car.

• *Stuck And Require Winching:* If you're stuck in snow, sand or mud we'll reimburse you to get yourself winched out.

Plus our Trip Interruption Benefits
can really save your day

One of the worst times for things to go wrong is when you're miles away from home. That's when expenses can really add up. And that's why we protect you with our Trip Interruption Benefits.

• If you're stranded due to an accident, we'll reimburse you up to $300 to cover rental cars, meals and lodging and commercial transportation.

• If hazardous weather forces you to find emergency accommodations away from home, we'll cover you up to $150 for lodging, food, phone calls and personal necessities.

• You can use our Personalized Travel Planning — FREE. Tell us where you want to go, if you want the scenic route or the most direct route and we'll send you an auto trip kit, with marked maps and tourist information.

• We'll supply a $1,000 reward if your car is stolen. Plus we'll give you partial reimbursement for up to 10 days of commercial vehicle transportation.

• We'll look after your legal fees up to $700 if you need a lawyer in court. And if you have a problem while in the U.S.A., we'll even provide up to $15,000 bail bond.

I don't have room here to list all the member benefits. Simply put, they add up to complete peace of mind for you, wherever and whenever you're travelling in Canada or the United States.

The Sears Auto Club gives you peace of mind
plus a whole lot more:
A FREE auto inspection worth up to $50

You're a Sears customer, and we know you appreciate value. Well, here's value you won't believe. An exclusive Sears Auto Club benefit — a free auto inspection worth up to $50.

When it comes to automobiles, a little preventative maintenance can save big repair bills. So we give you this free auto inspection to help you catch the minor problems before they become major — and to help make your peace of mind complete.

This benefit alone is worth more than your annual membership fee. Now that's value!

Sears Auto Club gives you the freedom
to always choose the service provider you want

Some auto clubs force you to use only the services that they specify. That restriction can often be a serious inconvenience.

Especially when you need a boost on a sub-zero day and all their members are trying to call the same numbers — and getting the same busy signal. When they finally do get through, who knows how long they'll wait until help actually arrives.

We make it a lot easier for you. The Sears Auto Club lets you call whoever you like. Fast, easy and much more convenient for you.

Mail your acceptance by the deadline and
you're protected for up to $300 from the day you mail it

Check the expiry date on your temporary membership card. Send your acceptance back to us by that date and you'll have the added protection of the enclosed Interim Claim Reimbursement Form.

PS: Everybody Reads the PS

And lots of people read it first, which is why so many successful direct mail letters have one, even letters directed to upper management. Because the PS is so powerful, the copy is used like a major headline. The PS can recap the offer, highlight a big benefit or persuade readers to look at the rest of the mailing. Or all three. The PS can:

- add urgency ("limited time offer");

- encourage action ("call your research consultant today");

- focus on any free gifts, bonuses or discounts ("*The Insider's Report*, yours free with . . . "); and

- give assurance ("100 percent money-back guarantee, no questions asked").

Your job as designer is simply to let the PS stand out and do its job.

No Other Face but Courier (or Prestige)

The rule of thumb for direct mail letters is simple: typeface and size of type should support easy reading and easy skimming.

Even though businesses these days use standard office typefaces like Times, Palatino or even Helvetica for their letters, many experts still believe direct mail letters should only be set in Courier or Prestige. The original idea was to make the letter look as if it were typed on a typewriter by a real live person instead of being mass-produced. Of course, the typewriter is long gone, but these typefaces have become traditional for direct mail letters.

If you're not a direct mail purist, or working for one, Times Roman (or the PC version Times New Roman) is an acceptable choice because it is today's standard business office letter typeface and it is a very readable serif face.

Using a sans serif typeface for the body text of a direct mail letter is taking a big risk. Sans serifs are not widely used for letters, so they cause people to stop for a second, feeling slightly perplexed. Sans serif typeface legibility is also sometimes less than optimum, and you want people to be able to skim your letter and never stop, feel irritated or wonder what character that was!

To support easy reading, the body copy of a letter should be an absolute minimum of 9-point and rarely more than 12-point type. The leading should use word processor defaults. The idea is to look like someone used an office or home computer to generate the letter.

Archive Subscription Mailing Letter

MARK CHEUNG and BETH CROWELL
CHEUNG/CROWELL DESIGN

This package has been the control for *Archive* for more than five years. The letter, directed to graphic arts professionals, breaks a lot of direct mail design rules. But it doesn't break the biggest rule: Know your audience. Know their prejudices, their likes and dislikes, their hot spots.

The letter is small, like a note, and says, "This won't take a lot of your busy time to read." It is very visual and it uses humor in a way that reflects the style of the magazine. It's set in sans serif.

But the rules of salesmanship are there. The headline delivers the big benefits and entices. You can figure out the offer in a split second. There's a great professional discount, an emphasis on "free," a "Send No Money Now" reassurance. Standard direct mail wrapped in a different package.

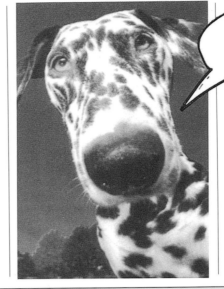

GRATISHEFT
36% RABATT FÜR ABONNENTEN.
EIN EINMALIGES ANGEBOT
SEHEN SIE SELBST! WUFF

*(FREE ISSUE
36% DISCOUNT
A UNIQUE OFFER.
SEE FOR YOURSELF! WOW)*

Dear Creative Professional,

Quelle Bonne Affaire!
(What a Deal!)

You'll see the BEST, NEWEST, FRESHEST, OUT-THERE advertising in the world in Lürzer's International ARCHIVE magazine.

Hundreds of ideas in every issue from the U.K., France, Holland, Spain, Brazil, Germany, Australia, Singapore… everywhere great work appears. New

forget inspiration.
think perspiration.
another set
of le..
another three miles.
another game of squash.
lose every excess ounce
of energy.
make your body
melt.

print ads, exciting photography, the best in TV commercials, sensational posters, new visuals, new concepts. ARCHIVE is a lifeline when you're up against a deadline. It's a great idea file. And you'll keep in touch with what's going on all over the world.

You'll discover it in ARCHIVE first! Long before it's recognized at the awards show… long before it hits the annuals… or anywhere else.

Inspección Gratuita
(Take a Free Look!)

Get your FREE ISSUE and see for yourself. Top creative directors, copywriters, photographers, graphic designers and agencies have subscribed to ARCHIVE for years.

Take a look. You'll agree with them that ARCHIVE's a secret weapon in a shrinking world.

Now, with this great offer, you can get in on their secret. (In fact, lots of our subscribers end up having ARCHIVE sent to their homes… it somehow 'disappears' at the office.)

Over 10,000 New Ideas a Year

ARCHIVE's an amazing idea file. It's organized into more than 30 categories. Agencies, Automotive, Beverages, Children, Cigarettes/Cigars, Corporate Identity, Food, House & Garden, Environment, Pharmaceuticals, Retailers, Services, Sports, Travel & Leisure… to name a few.

Then there's the CLASSICS section at the end of every issue. You'll see the great ads or campaigns that made history. Timeless, brilliant and still effective — another wonderful source of ideas.

And it's a beautiful magazine! First class typography. Silky, rich paper. Gorgeous full color.

You'll always know who did the work. ARCHIVE identifies the creative talent in captions. We give credit where credit is due.

You'll always know what the ads say. We translate right there.

Meet a World Renowned Creative Genius in Every Issue

Verbatim. Straight from the likes of: Paul Arden, Creative Director, Saatchi & Saatchi, London. Leslie Decktor, Los Angeles. Washington Olivetto, founder W/Brasil. Alan Waldie, Art Director, Lowe Howard-Spink, London. Mike Tesch, Amil Gargano & Partners, USA. Teofilo Marcus, Jose Maria Lapena and Juan Marian Mancebo, Contrapunto, Spain.

The interviews are in-depth, never boring and quite extraordinary. You get inside the world's top creative minds — and only in ARCHIVE!

Formats and Paper Choices

The most common paper choice for a direct mail letter is a 60# white offset. Black type on white paper is easiest to read, and since getting people to read is what we're after, that's what you see most often.

If you're trying to imitate note paper or invitation styles, you might want to use beige, grey or ivory papers. If you're mailing to an audience for whom environmental awareness is important, it may be worth the extra money to use recycled papers. But if you're trying to drive your cost per thousand down, this may not be an option.

When you're selecting your paper, don't forget to take weight into account. If you are mailing at First-Class rates, you'll want to keep the mailing weight

below one ounce. Also, if you are printing on two sides, remember to take paper opacity into consideration.

Letter size usually is determined by the envelope size and the common sizes of personal and business stationery.

A common format is the four-page booklet letter, which lays the letter out on at least three of the four pages. This format supports long copy development, keeps people reading, and perhaps even feels like a story.

One-page, single-sided (short and sweet) letters are what work most often in business-to-business mailings designed to get leads—i.e., get people to say they are interested in more information or otherwise identify themselves as someone to be contacted again. If you were to design a multipage letter for a business audience, you might use separate sheets, printed on one side. In other words, you would imitate one-to-one business correspondence.

Most direct mail letters are two-color—black and a spot color. If you use four-color photography in the letter, it's okay to use a coated stock, but remember that coated stock for a letter really says this is a "commercial" letter, not a personal one. If the letter is wonderful and effective and needs four-color reproduction, then that's no disadvantage.

Back to Your Mailbox

In the final analysis, the design of a direct mail letter is only great if it generates response. It can't be emphasized enough that the best way to learn what works is to start collecting the direct mail you get repeatedly. When you see a mailing more than once, it probably means it's the control—that is, it has won against other mailings that were tested against it. And that's wonderful information when you're new to direct mail. You don't have to search out what works. It will come to you!

The Response Device

or

YES, Please rush me . . .

Response devices in direct mail are anything a responder uses to mail back, fax back, phone back or E-mail back. They include mail order forms, reply cards, pledge envelopes and a myriad of other formats.

Many experts think the response device is the most important component of a mailing. Although it can't deeply interest readers in your proposition and it doesn't explain the benefits in detail, the response device is the decision pivot point. It's the point of transition from solicitation on your part to acceptance and response on the part of the reader. So if you don't have an effective response device, none of the other components can function at all.

Think of the response device as the "closer" in the sales process.

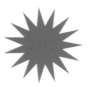

Use the Attention-Getting Nature of the Response Device

Many people go to the response device first to get a quick-and-easy summary of the offer. Readers subconsciously use the response device to see if the mailing is worth looking at further. Some people even respond right then, without looking at anything else.

There's another interesting reason people look for the response device. People give surprising attention to their own names and addresses, even examining them closely for misspellings or any other kind of mistake. It's a form of entertainment, a game. And the place they're most likely to find their own name and address in a mailing is on the response device.

So the response device is a real magnet. It's the one component in the package that will show the greatest impact on results when you improve it. And it's also the component where the most damaging mistakes are made.

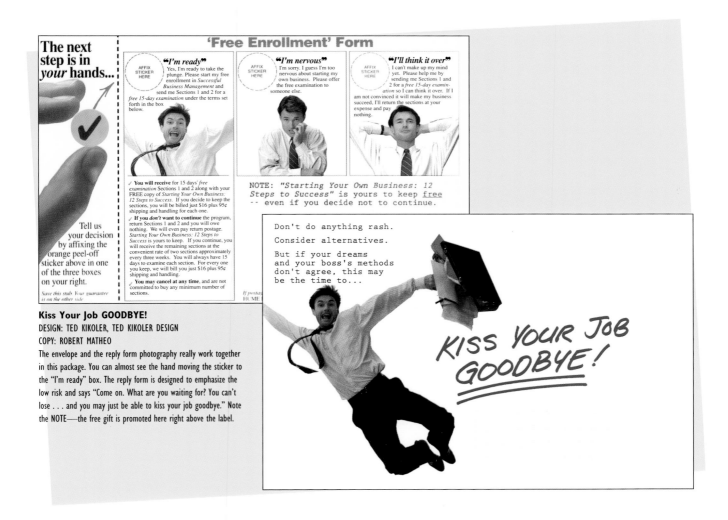

Kiss Your Job GOODBYE!
DESIGN: TED KIKOLER, TED KIKOLER DESIGN
COPY: ROBERT MATHEO
The envelope and the reply form photography really work together in this package. You can almost see the hand moving the sticker to the "I'm ready" box. The reply form is designed to emphasize the low risk and says "Come on. What are you waiting for? You can't lose . . . and you may just be able to kiss your job goodbye." Note the NOTE—the free gift is promoted here right above the label.

Make Sure It's Easy to Find

Your first instinct might be to hide the response device, to make sure it's not seen until after the letter or the brochure because only then will the reader understand what it is you're trying to sell or get her to do. And because most people are reluctant to sell strongly, you might be tempted to underplay the response device. Wrong.

Since the response device is the pivotal point in getting a person to move from consideration to decision, it should be emphasized.

Make the response device do its job. Don't be afraid of soliciting, or drawing attention to the sell copy. In direct mail, it's key to solicit and be directive. Highlight the copy that urges people to respond now.

Clearly identify the response device as the way to reply. You can make it more important by giving it a valuable name. Here are some suggested labels:

Reservation Certificate

Free Trial Acceptance

Free Gift Voucher

Special Savings Voucher

No-Risk Trial Certificate

Reservation Card

Discount Offer Form

Professional Courtesy Reply

Request Card

Reply to Your Invitation

RSVP

Charter Offer Order Form

Another technique is to make the response device look valuable by designing it to resemble a stock certificate or an award, or by using the green of U.S. currency as an accent color.

Tip

Do the tap test yourself. Tap your reply envelope on the right, left and bottom sides to make sure the response card doesn't shift and the clearances are maintained.

Use symbols of "value" like certificate borders, starbursts with the word "Free," and attention-getters like boxes pointing out the time limits on the offer, official-looking computer type for codes or certificate numbers, and rubber stamp type styles for copy like "RUSH" and "Limited Time Offer."

Bright colors, exciting design, photos, paper stock different from any other element in the package, bold type—they all can make the response device stand out. Except for upscale financial mailings, fund-raising mailings, very businesslike mailings to executives or mailings that are trying to look official, the response device can be visually exciting and energizing. Just make sure the visual excitement doesn't interfere with the responder reading what he needs to read and writing where he needs to write.

Country Home Folk Crafts
NANCY DAVIS, MEREDITH CORPORATION
Find all the response generators . . . YES! Rush me. New! Mail Today. Absolutely Guaranteed. Send no money now. The token slot is a classic Meredith technique—the responder is involved physically and psychologically by inserting the token into the slot. It is an act of commitment but the emphasis is on what you are getting free, reserved especially for you.

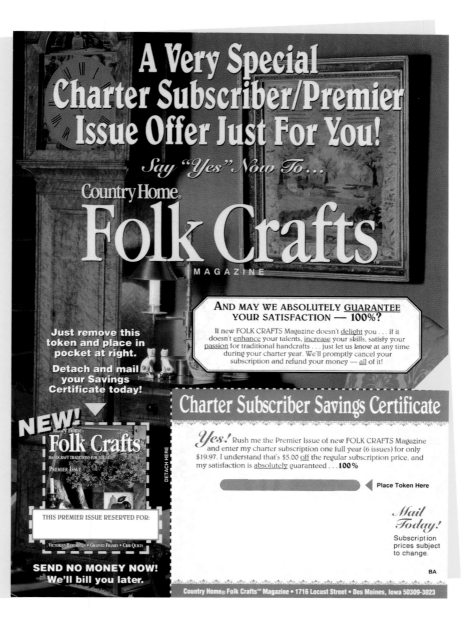

Make It Easy to Respond

The response device should be easy to fill out. Your design should make it crystal clear how to respond—so easy a ten-year-old child understands it. It should be very directive. Tell people exactly what to do.

Ideally, the responder's name, address and other information should already be printed on it, because you want to make responding as easy as possible.

If the responder has to fill in any information, make the spaces big enough to write in without resorting to tiny, cramped handwriting. Don't annoy people who are trying to respond. Likewise, choose paper stock that can be written on without a struggle—uncoated stocks with white or light backgrounds are usually best.

Find out if the response card is going to be scanned when it is received. If it is, be sure each area of information can be read by the scanner and that the paper stock can be handled.

If the response form has to be lengthy (as with credit card applications), organize the information with banners, numbering and other graphic devices

EATON and Petro-Canada
RON MARSHAK, RON MARSHAK DIRECT MARKETING
Listing the benefits on the reply is one way to boost response. Many times the reader goes to the response device first to get a summary of the offer. And if the benefits are recited on the form along with the instructions to respond, you are already starting the reader on the road to responder. In fact, sometimes that's all that's needed.

Tip

Looking at the color red quickens the heart rate slightly and releases adrenaline into the bloodstream. That's why it's good for response devices.

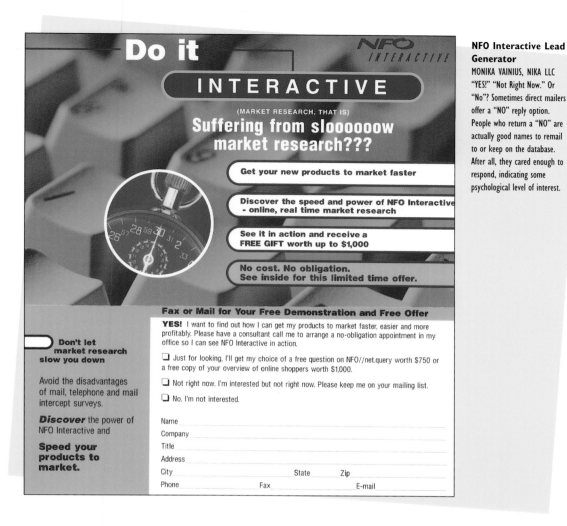

NFO Interactive Lead Generator
MONIKA VAINIUS, NIKA LLC
"YES!" "Not Right Now." Or "No"? Sometimes direct mailers offer a "NO" reply option. People who return a "NO" are actually good names to remail to or keep on the database. After all, they cared enough to respond, indicating some psychological level of interest.

that make it look like it will take very little time to fill out. Make the form as self-explanatory as possible.

The response device should fit without folding in the Business or Courtesy Reply Envelope. Avoid any other inconvenience.

Make It Easy to Read

Use easy-to-read type for the acceptance statement, instructions, options and any benefit copy. If your target audience is senior citizens, make the point size a tad larger than what you'd use for a younger audience.

If you have several acceptance options, set the option you want people to choose in larger type than less desirable options.

If you have to include legalese or disclaimer copy, separate it from the acceptance and benefit copy. Make it look as unintrusive and friendly as possible.

YES! Have a YES! Acceptance Statement

Remember when you're designing the response device that its job is to make a forceful statement of acceptance.

The acceptance statement summarizes the principal rationale for responding. It makes the statement of acceptance, encourages action and includes a major benefit. That's why direct mailers use the word "Yes!" standing out, followed by a supporting thought that summarizes the key reasons why the offer is being accepted (for instance, "YES! Please reserve my free copy of *Thin for Life* and rush me . . . ").

Nightingale Conant 7300 North Lehigh Ave, Niles, IL 60714 • Call Toll-Free 1-800-525-9000 • Fax Toll-Free 1-800-647-9198

A D V A N C E N O T I C E

F R E E T R I A L O F F E R

PRE-CATALOG ANNOUNCEMENT. YOUR PARTICIPATION IS REQUESTED.
PLEASE LET ME KNOW YOUR ANSWER BEFORE MAY 27TH, 1997

CUST# NC006263834 DJGQCDA

Eileen Kelly
St. Joseph Hospital
703 Main St.
Paterson NJ 07503-2621

Dear Eileen Kelly,

Mr. Conant asked me to send you the enclosed free trial offer because, based on what you've purchased from us in the past, he believes you'll be interested in this new, breakthrough audiocassette program from Brian Tracy. It's not available in the catalog yet.

You, along with a select number of our customers, have been invited to be among the first to sample an exciting breakthrough audiocassette program from Brian Tracy. There is no charge. I've already arranged that you'll receive the program free for 30 days. If, after listening to it, you decide that you don't care for it, just send it back. It won't cost you a penny.

But if you'd like to keep it, just pay the invoice that comes with it. You're price is only $59.95 plus shipping, handling, and applicable sales tax.

Vic's special report explains everything. Please read it and let me know whether you're interested in participating in this 30-day free trial. There's no order form. To get your free trial copy, just check off the "YES" box below and return this page to my attention.

[] YES, I accept Vic's free offer to listen to Brian Tracy's new audiocassette program, "The Luck Factor," free for 30-days.

[] NO THANK YOU. I will not have time during the coming month to participate. Please give my free-trial copy to someone else.

Please fax this page back to me toll-free at 1-800-647-9198, (no cover page needed), or use the enclosed reply envelope. Or, if you wish to call our toll-free order desk at 1-800-525-9000, just mention your claim number below.

Thank you for your cooperation.

Sincerely,

Maggie Raimo

Maggie Raimo,
Assistant to Vic Conant

ENCLOSURES

cc: Vic Conant, Gene Semmelhack, Sara Pond, file

FREE OFFER CLAIM No.

DJGQCDA - 006263834

15360-OC

The Luck Factor Audiocassette Program
TED KIKOLER, TED KIKOLER DESIGN
The writer/designer wanted to draw people in and make this look like a special, small quantity mailing. He wanted the reader to feel there really is a person whose job is affected by this mailing, who cares about it. So the reply form looks like a letter from the "Assistant to Vic Conant" for an Advance Notice-Free Trial Offer. The office formats—"ENCLOSURES" and "cc:"—make the reply form feel less like direct mail and more "real." The "Free Offer Claim No." draws the eye, while connoting credibility. Turn the page over and there are handwritten instructions from "Maggie" on how to fax back your reply.

Make the design focus people on the act of responding:

- Use a YES! acceptance statement with a prechecked box in front of the "YES!"

- Provide check boxes for options.

- Use dingbats—pointing fingers, telephones, scissors—and icons to telegraph how to respond.

- Get people engaged with involvement devices—like peel-off stickers from some other part of the mailing to move to the response device.

- Make the response form look inviting and easy to fill out.

- Emphasize the toll-free number, fax number, phone number and/or mail-back address.

The response device also offers acceptance options, such as method of payment or expressions of interest that don't go as far as accepting the offer ("Keep me on your mailing list" or "Send more information").

Codes on the Reply Form

Direct mailers want to track results, so often key codes are printed along with the recipient's address to identify what list the name came from. Sometimes there's a customer code too. These codes are ink-jetted or otherwise printed at the same time as the name and address.

If there are several versions of the mailing, say an offer test, the mailing will be coded for the offer. Occasionally, there are different toll-free numbers to call for different versions of the mailing.

When to Use a Separate Component

In envelope mailings, a separate component is preferred. You can save money by not having a separate response device—using a tear-off reply on the letter or printing the response device in the brochure, for example—but most of the time you'll run the risk of lower response.

In self-mailers and magalogs, the reply is not separate, of course. It's usually on the last page.

Business Reply Mail: Envelopes and Cards

If you ask the responder to go find a stamp and put it on the reply envelope or card, you interrupt the act of responding and may lower response. If you want payment with the order, credit card information or any private information (like phone numbers or E-mail addresses), a Business Reply Envelope (BRE) is a necessity. You don't want a potential responder to decide not to respond simply because you didn't supply a BRE.

So advise your clients to use Business Reply Mail (BRM)—that is, provide postage-paid reply cards or envelopes. To use BRM, you have to apply to the USPS for the permit and pay all applicable fees. Small-volume or infrequent direct mail users might go for the option of paying postage and fees for each returned piece of reply mail when it is delivered to them. However, for high volumes and to pay the lowest rate, a debit account established with the USPS makes more sense.

A unique ZIP+4 code is issued to each BRM permit holder. A camera-ready bar code positive is available at no charge from the Post Office. The bar code must be placed in the bar code clear zone in the lower right corner (4¾ inches long from the right edge, (⅝ inch high from the bottom edge) of the envelope. It cannot be placed below or above the address block as it can be on regular mail.

A Facing Identification Mark (FIM) is required on Business Reply Mail. The FIM is a pattern of vertical bars printed in the upper right of the envelope just to the left of printed indicia. It's needed as an orientation mark for automated facing and cancellation equipment. You don't have to design the FIM yourself—a camera-ready positive is available at no charge from the post office.

The USPS recommends black ink on a white background for the FIM and the bar code, but you can use other colors. According to the USPS, Pantone Matching System (PMS) ink colors with a minimum of one-part black are acceptable.

Light background colors for Business Reply Mail (cards and envelopes) are safe. Forget fluorescent stock. It interferes with the functioning of USPS address and barcode reading equipment.

Tip

Self-mailers used for reply mail cannot be stapled closed when returned, whether you're using BRM or not. You have to design them with continuous gum strips or glue spots to keep them closed, or instruct the responders to tape them shut.

In Case You're Wondering

If you have questions or concerns about your BRM, take it to a local USPS Business Center and get a Postal Service mailpiece design analyst to review it. Business Centers were established to help mailers (especially local businesses trying to do direct mail) meet USPS regulations. You can get a list of them from your local post office. You can also just ask for help at your local post office. Letter-shops know this stuff too.

The Tap Test for Outgoing Window Envelopes

Design the reply device so it fits snugly if you use a window outer-envelope. Remember, the USPS can perform the "tap test" at any point in handling your mail. All the tap test means is that if your mailing is tapped on the right, left or bottom, the bar code and address block can't shift and end up outside the required minimum $^1/_8$ inch clearance to the sides and .04 inch to the top and bottom of the window edges. If a single piece fails, the whole mailing can lose all automation discounts.

Help From the Postal Service

The *Domestic Mail Manual* (DMM) gives you all the preparation and the application procedures for Business Reply Mail, but it's not that easy to read. There is also a USPS publication called *Designing Reply Mail* that gives you the information on preparing Business Reply Mail—cards, self-mailers or envelopes. Also available from the USPS is a template you can use to be sure the FIM (Facing Identification Mark) and other information is placed correctly.

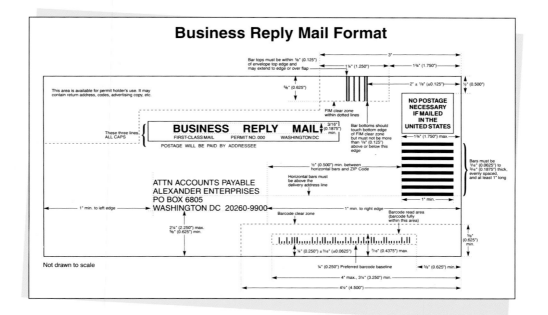

Business Reply Mail Format

Stubs and L-Shapes

That brings us to tear-off stubs on the response device. The stub can have a double function. First, it ensures the response device will be large enough to fit snugly in the outer envelope and not move out of position (so that you'll pass the tap test). Then, when the responder perfs out or cuts out the reply part of the response device, it's exactly the right size to fit in the BRE. (Having to fold the reply form to fit in the reply envelope is considered to be an irritant to responders and therefore likely to lower response.)

The other thing stubs do is promote action and give your responder something to keep. Plus, if the offer might qualify as a tax deduction, you can promote that benefit on the stub—tell the responder to tear it off and keep it for tax records.

A variation on the utilitarian tear-off stub is the L-shaped response device. It's hard to miss an L-shaped response form in the envelope. And that's exactly why it works. It gets attention and invites hand-

Try Designing the Response Device First

This can be really hard to do, but an excellent exercise is to create your response device first and then design the rest of the package around it. The other pieces in a mailing package are designed to get people to take action on the response device, so lead them to it visually and psychologically.

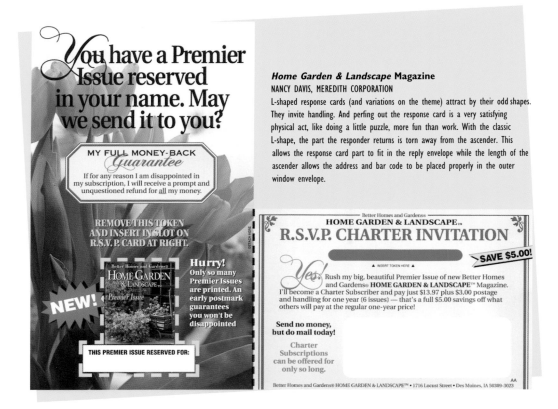

Home Garden & Landscape Magazine
NANCY DAVIS, MEREDITH CORPORATION
L-shaped response cards (and variations on the theme) attract by their odd shapes. They invite handling. And perfing out the response card is a very satisfying physical act, like doing a little puzzle, more fun than work. With the classic L-shape, the part the responder returns is torn away from the ascender. This allows the response card part to fit in the reply envelope while the length of the ascender allows the address and bar code to be placed properly in the outer window envelope.

ling. The ascender part of the L is used to list benefits, promote action, be visually exciting. The horizontal section is the response device and gets torn off and sent back. The L-shape requires a die cut and isn't as cheap as a plain rectangular card to produce, so like all things in direct mail, the L-shaped response device has to pay its way.

Backside Philosophy

There are three schools of thought on printing on the back of the response form: Yes! No! and It Depends.

The "no" school thinks it distracts people in the act of responding. To quote direct mail guru John Klingel, "Anything that slows response lowers response."

The "yes" school thinks, "Here's another opportunity to sell." Besides, you don't know which side the reader will see first, so you ought to use both.

The "It Depends" school analyzes each mailing and decides if using both sides works for the audience, the product, the type of mailing, etc.

If you're not that experienced and want to be absolutely safe, forget the copy on the backside of the card. Make the front strong and clear and let it do its job.

Attention, Desire, Action

To sum up, the response device has to:

- get attention;

- sum up the offer; and

- close the sale, i.e., inspire the desired response.

And it should be able to "close" on its own. The reader shouldn't have to look at anything else in the mailing to know this is a great offer and here's how to respond—now.

Check Out Your Response Device

- Is it easy to understand?

- Is it easy to find?

- Is there a clear statement of the offer?

- Does it highlight the benefits?

- Does it encourage action?

- Does it spell out how to respond?

- Does it highlight the guarantee?

- Are price and terms clear?

- Is the sales tax spelled out?

- Are shipping and handling costs indicated?

- Is delivery time stated?

- Are time limits stated?

- Are any rules and regulations handled positively?

- Is the return address included on reply form?

- Is phone, fax and E-mail information included?

- Does it fit in the reply envelope easily? Without folding?

- Did you ask for change of name and address?

- If possible, are name and address of responder already filled in?

- Is postage-paid return provided if payment with order, credit information or confidential information is requested?

Brochures

or

Not Just a Pretty Face

The way the brochure looks, feels and unfolds should be like a siren's song of sales psychology. The brochure can show off your product or service to the highest visual advantage. It captures and projects the benefits the copy promotes with photos, color and typography, deploying all the tools of the designer's trade to seduce the reader and overcome any doubts.

In consumer mailings, the brochure embodies the emotional concept of the copy--it shows the readers projected into the new world they'll have once they buy the product or service . . . how they'll be happier . . . how they'll be admired . . . the lovely projects they'll make. All the wonderful things that will happen. In business-to-business, it can contain written information too detailed or lengthy to include in the letter. It can "explain" with photos, drawings, diagrams, charts, tables and graphs, performing a function a letter can't--and shouldn't-- if it's to maintain any semblance of personal mail.

Open ME

Brochure design needs to create a visual eye-path that's unrelentingly sales oriented, pulling the reader in at every turn. Which does not mean neat and boring. Screaming headlines, arrows or circles that look like they were just done with a marker are all allowed in direct mail. So is quiet elegance. It depends on the approach of the whole package and what you think the audience will respond to. Or you test which approach works. Will a financial newsletter do better with a screaming magalog-style brochure or with quiet, dignified copy and design? The results can surprise you.

The one thing you can count on is that your brochure will be read "out of order." So whatever the style, everywhere the eye stops, be sure it encounters a reason to respond and built-in movement to the next place you want the reader to look.

The Whole Story in the Heads

A strong master headline on the outside cover helps to get the reader to open the brochure. Standing on its own, this headline should also communicate the message of your piece. Interruptive heads are a tried-and-true direct mail technique. All that means is that the head is broken so you have to open the next panel to read on. Sometimes that's accomplished with an ellipsis . . . and sometimes the thought is actually broken.

Inside, headlines and subheads together should tell the whole story, even if not another word is read. In fact, most readers only read the headlines. Readers skim and scan, looking for highlighted copy, so give them eye-stops. You'll find

How to Get Brochure Copy Read

- Body type should be set in a size readable for the age group targeted: 9-point type is the minimum for any age audience. Two to four points of leading supports comprehension for extended copy reading. Wider leading can add white space and create interest in short blocks of copy.
- Serif body type generally beats sans serif for ease of reading.
- Use sales-oriented captions with photos, charts and diagrams.
- Use eye-stoppers such as call-outs and quote-outs to support the sales pitch psychologically.

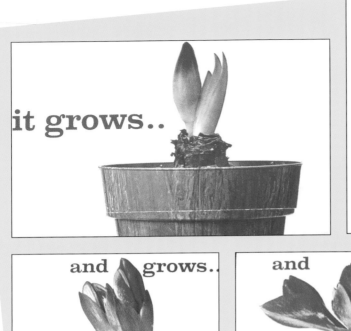

it grows..

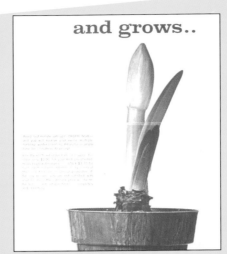

and grows..

and grows..

and grows..

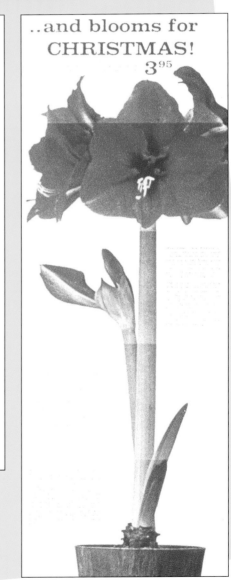

..and blooms for CHRISTMAS! 3⁹⁵

Amaryllis Brochure
DESIGN: RICHARD B. BROWNER, RICHARD BROWNER, INC.
COPY: CHRIS STAGG

Richard recalls this memorable direct mail collaboration with Chris Stagg, a copywriter and decade-long colleague of Richard's:

"Chris was to write, and I design, a 6" x 9" package selling amaryllis plants. The design could easily have been quite traditional in concept and, as such, I'm sure been perfectly acceptable. We had a slew of transparencies from the client, all of which were 2¹/₄" x 2¹/₄" shots of blooms. These plants grow to a height of nearly thirty-six inches and I thought—wouldn't it be great to show the plant not only life-size, but to illustrate its actual week-to-week growth. Chris agreed. And so the brochure was designed before the copy was written.

"We grew an amaryllis in the photographer's studio, where every few days he photographed its growth. I took a sheet of paper, something in the nature of 36" x 8¹/₂", and created a series of panels which unfolded up, so that when the recipient began unfolding, the plant grew before his eyes—to full size.

"It's this kind of project, working with a writer who recognizes the value of design as a strong adjunct to words, that can make aspects of direct mail very satisfying."

that lots of direct mail brochures have strong master sales headlines that are relatively long—up to twelve or fifteen words. The design has to accommodate them.

Typographic research finds no significant difference in readability whether headlines are set in serif or sans serif. All-cap headlines, on the other hand, are somewhat more difficult for most readers. They are read more slowly.

A Brochure Is a Many Folded Thing

Brochure formats and folds are really unlimited. Brochures can fold down to be very small and can fold out to what's called poster size.

The impact of a brochure can be strengthened by the way it is folded—the unfolding should have an almost organic, natural feel to it. The paper should not merely be there, just a surface on which you lay ink and pictures. It should be used to add drama to your sales story and open itself in a logical and compelling sequence.

One common mistake made in brochure design is "panelizing" the sales message. What that means is that one panel gets all the features copy, one panel gets all the benefits, one panel gets the pictures, one panel gets the response form but no sell copy . . . everything is too compartmentalized.

Almost every panel standing alone should make the reader want to respond now. The design should support moving from panel to panel, fold to fold quickly with a compelling sales message revealed everywhere. When the brochure is totally unfolded, the entire story should be in front of the reader, and "how to respond" should stand out like a sore thumb.

Try to run inside headlines or copy blocks across two or more panels. The technique broadens the visual field and increases the odds the reader will see something he needs or that entices.

Brochures are used for any or all of these reasons:

- to help the reader visualize using the product or service
- to help the reader visualize the fantasy, the dream the copy projects
- to detail the information presented in the letter
- to educate
- to dramatize
- to give credibility
- to explain
- to impress
- to tell a story
- to involve with color, photos and illustrations
- to demonstrate how the product or service works
- to prove claims using testimonials, research results, comparison charts, etc.

Utne Reader ▶
DESIGN: DAVID WISE,
WISE CREATIVE SERVICES, LTD.
COPY: KEN SCHNEIDER

◀ *Country Home Folk Crafts*
DESIGNER: NANCY DAVIS, MEREDITH CORPORATION
Here are two apropos answers to "how much is needed?" and "what to show" brochure questions. The *Utne Reader* brochure is information-heavy, the *Country Home Folk Crafts* piece is image-heavy. Each helps its unique target audience to respond.

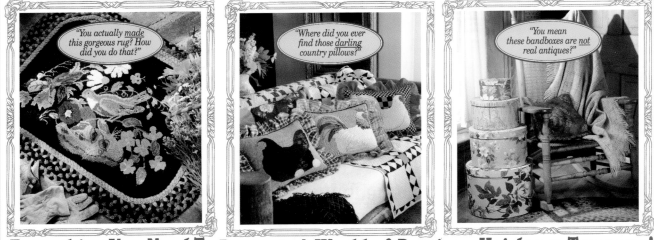

DirectNET Real Estate Marketing Service
BETH CROWELL, CHEUNG/CROWELL DESIGN

Realtors know doing repeat mailings to a target market is a profitable marketing strategy. But they're so busy selling that few take the time to market. Pitney Bowes DirectNET Real Estate Marketing Service offers a postcard mailing plan that makes it easy at a great price. This twelve-page, self-cover brochure had to sell the idea plus show all the postcards (like a catalog). And get across the pricing. And answer any questions. Additionally, the brochure was designed to present the limited color choices for the postcards very positively. The bright primaries are very inviting—the opening fields of yellow and red were selected to promote optimism and energy. The 800 number and the list of freebies are printed on every spread.

DirectNET sm
REAL ESTATE
Marketing Service

POSTCARD PROGRAM

FREEOFFER

Pitney Bowes

Pitney Bowes *DirectNET* REAL ESTATE Marketing Service
is your "one stop" solution for high-impact postcard mailings.
All it takes is one phone call: 1-800-685-0620, ext 326

Free mailing list use
Free list consultation
Free mailing

Pitney Bowes

Increase your listings, sales and referrals with no extra work

You'd like to talk personally to everyone in your market area.

But that's near impossible. So why not do the next best thing.

Talk to each of them with a postcard.

"Great idea," you say. "But who has the time to keep up a mailing program? And mailing once or twice is useless."

Right on both counts. No one has the time and you certainly do need to mail often. That's why Pitney Bowes created *DirectNET* REAL ESTATE Marketing Services.

Make just one phone call to *DirectNET* REAL ESTATE and you can "talk" to hundreds of prime prospects.

Marketing
to your
sphere is now
easier and
cheaper
than you can
imagine

POSTCARD PROGRAM

Sign up now for our 6 Postcard Plan and you'll get the 6th mailing **Free.**

For as low as 30 cents each, we'll do a targeted, personalized color postcard mailing to your sphere market. That includes everything — design, printing, your logo in black, First-Class postage, addressing, mailing — we'll even help you choose your mailing list. Your use of the list is **Free** for each mailing too!

Between the special price and the free mailing, you can save up to $1,080 over the regular cost.

And with ten different postcards to choose from, you've got the right card for every situation. Here's our suggested plan. But you can change the cards or the schedule.

Suggested 6 Postcard Plan	
September	❶ Let's Talk
October	❷ Free Market Evaluation
November	❸ Holiday Greetings
January	❹ Free Market Evaluation
February	❺ Spring Sales
March	❻ 3 Top Tips
4 Optional Cards	❼ Just Sold
	❽ Just Listed
	❾ Dreams
	❿ Buying

We'll take care of putting your name and address here.

And putting your name and phone number here.

Let's talk

We can give you comparative market information.

Agency name
Address line 1
Address line 2
City, State Zip

help you find your new home. **help you sell your home** or **provide**

financial and real estate investment advice. I also offer a **free written market evaluation** of your home. Just give me a call. I'd be glad to help.

Contact name
contact phone

**Buying?
Selling?
Just thinking
about it?**

And we'll put your logo in black here.

The Variable Information on Your Cards
When you call us to order your cards, your *DirectNET* consultant will ask what you'd like put in these areas on the card. Just turn the page to see all the card designs offered.

1 Tell us the return address information you'd like put on the address side of the card. Your name? Your agency? Both?

2 On the message side of each card, an area is reserved for the contact name and any other contact information you want to print.

3 The design of each card also accommodates printing your logo (in black). For fastest service, send your logo electronically.

Please turn the page to see all 10 postcard designs. ▶

The Pleasures of Gevalia Kaffe Import Service

Gevalia Kaffe
MARK CHEUNG AND BETH CROWELL,
CHEUNG/CROWELL DESIGN

The tiny little doll-house-sized booklet brochure for Gevalia Kaffe just makes you want to turn the pages. The superiority of the coffee and the free designer coffee maker are shown off by the elegant type and the look of "specialty" paper. But the surprise is that the paper is created by four-color process, making the brochure extremely cost-effective.

Gevalia® Kaffe. Purveyors of coffee to the Swedish Royal Household for four generations.

Now available to discerning American homes only by mail through Gevalia Kaffe Import Service.

GEVALIA KAFFE

By Appointment to His Majesty the King of Sweden

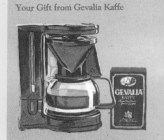

Your Gift from Gevalia Kaffe

We are pleased to give you our European-style coffeemaker *free* with your $10 order of a Trial Shipment of Gevalia. *It is yours to keep, no matter what your decision about Gevalia Kaffe Import Service.* We believe in Gevalia so strongly that we are willing to make this valuable offer to introduce you to our fine coffee.

HOW Magazine
DESIGN: DAVID WISE, WISE CREATIVE SERVICES, LTD.
COPY: JOSH MANHEIMER

The winning package that included this mini-brochure demonstrated a key direct mail strategy—beating another package by getting costs down. The package got the same response per thousand as the control but beat it by being cheaper to produce. And the mini-brochure played a key part in the strategy. It's hard to ignore that eyeball staring straight at you. Open and you literally see *HOW* magazine in action—key business articles, how to make money, how to meet and beat the competition and how the top names do it too. And the wrap-up is how to get your free gift and free issue.

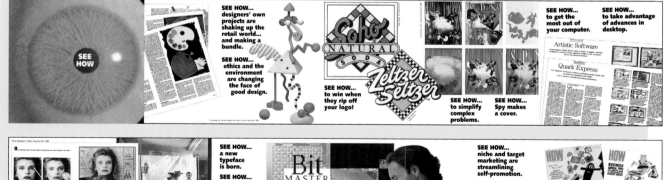

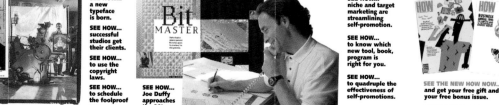

Remember, the brochure is a two-sided thing too. Some folds are seen only in passing—use them to move the reader along. Don't put the most important copy on the "dead" folds.

Brochure Conundrums

Would you believe that many packages do the same or better without a brochure as with one? The letter is essential, the brochure could be optional. Some direct mailers even believe an exciting four-color brochure only takes away from the letter, the most powerful selling tool.

When you're deciding whether you need a brochure and what kind, ask yourself these essential questions:

- What does the emotional appeal to the audience demand?

- What does the product or service demand? What needs to be shown to get the response you want?

- Should the product be shown in use or should the benefits of the product be depicted? Are you selling the steak or the sizzle?

- What senses are you trying to appeal to? What should the balance be between visuals and words?

Because it's usually the most expensive element in a mailing, direct mail pros try to figure out ways to drive the cost of the brochure down. They look for the least expensive paper that will do the job, ways to cut down on four-color cost, etc. Clients are ecstatic if you can use existing photography, and many times that's all you're given to work with. Anything you can do to reduce brochure cost while keeping the design integrity and power is a critical direct mail design skill.

Laying out the brochure so you get the most out of standard printing sheet papers and press sizes is another part of the art. Most large-volume jobs are printed on web presses with in-line trimming and folding.

Putting a Second Response Device in the Brochure

You can put a second response device in the brochure. Many direct mailers title or label this second response device to differentiate it with something like "Tell a Friend" or "Pass This Along to Someone You Like." With that kind of label, the second response device can get some passalong value for the mailing plus tell a reader how to respond without having to look at anything else in the mailing. So it performs a dual function.

Visual Seduction

The role of the brochure is to seduce the viewer with a more visual presentation of information and the sales pitch. It has to hook those people who would not respond without the added assurance the brochure gives them. The brochure can be beautiful, but all it has to do is pay its own way. If it's included, it must be because the package without it is incomplete, can't work. The brochure can't be just another pretty face, so to speak. It has to be essential to the sales message or raise response by an acceptable percentage when it's added. When you think about it that way, making a direct mail brochure work is an awesome responsibility.

Tip

It's a good idea to have the sending company's name, address and phone, fax, E-mail numbers and other contact information on the brochure. Ask yourself, "If someone finds this brochure in the garbage without any other part of the mailing, would they be able to respond?"

Lift Letters, Buckslips, Freemiums, Etc.

or

What's All That Extra Stuff?

If it's not the letter, if it's not the brochure and if it's not the response device, it's an insert.

Inserts are an "extra" element in the direct mail package whose sole purpose is to increase response. While there's really no limit to how many inserts a package can have, you rarely see more than three in addition to the basic letter, response device, brochure and outer envelope. Why? It costs money to add an element. Plus at some point too many elements might just plain confuse the reader. Always think about adding inserts to tweak interest and response.

Lift Letters

The most glamorous among the inserts is the lift letter, or as it was originally known, "the publisher's letter." You may have seen notes in subscription solicitations with copy like "Read this only if you decided not to subscribe." Or "Frankly, I'm puzzled . . . " That's the lift letter. The lift letter got its name because when it was first used for circulation mailings it always "lifted" response. Then it was copied to death, so it is no longer a guaranteed response raiser.

You'll see the lift letter in almost any format: note, memo, telegram, news release. Its function is to present the offer or to persuade in a different way than the basic letter. Most frequently, it's designed to be the size of a folded note. If it's signed, always use the name and signature of a different person than was used in the main letter. The note format has a headline on the outside fold and the note is laid out according to the same general rules as the letter:

- headline at the top (optional)

- short paragraphs

- subheads (optional)

- highlighted copy—indents, bulleted lists, underlining, handwritten messages

- PS (optional)

Please—don't just judge this book by its cover...

PERENNIALS
ALICE WILLIAMS,
RODALE PRESS, INC.
A lift letter that reminds you of a plant—it's long, tall and green. The letter, which begins "Dear Fellow Gardener," is signed by the president of Rodale Books.

"Rarely, can one cookbook have such an immediate and positive impact on the health of you and your family."

797C

WHAT HAPPENS IF YOU GET GLITTER AND CRUMBS IN THE BOOK WHILE YOU'RE HOME-TESTING IT?

See Inside!

Here's how your "Try It Free... We Pay The Postage" Guarantee works...

JOAN DENMAN

Dear Friend,

It sure is confusing! One day eggs are considered good for you. The next day they are not.

One day scallops and clams were thought to be high in cholesterol. Now they're considered low.

Unless you read medical journals every day, it's hard to keep track of which foods are best for your heart and your health.

So how can you know what's right to eat? Where can you turn for delicious AND nutritious meals?

Relax. Now today's most important medical breakthroughs have been translated into more than 350 heart-healthy recipes and menus ... and assembled into one extraordinary new book ... for concerned people like yourself!

Best of all, the Publishers inform me you can preview a personal edition in your own home free for 30 days.

Rarely, can one cookbook have such an immediate and positive impact on the health of you and your family.

I recommend that you mail back the enclosed Free Preview Certificate as soon as possible.

Cordially,

Joan Denman
Joan Denman
Food Editor

797C

$2,000,000.00

for a

first novel...

EXTRA CHANCES TO HIT THE HOT SPOT
DAVID WISE, WISE CREATIVE SERVICES, LTD.
(top left, bottom left, top right, bottom right)
NANCY DAVIS, MEREDITH CORPORATION (middle left)
Here's a group of inserts from several different mailings that shows how inserts are used to hit a single hot spot or give the appeal another spin. The headlines on the outer fold are for the most part quite long and are the only design element. And they're a testimony to the importance of copy in direct mail. The treatments are very straightforward: copy on a background that catches the eye. The "WHAT HAPPENS IF YOU GET GLITTER . . ." and the "Here's how your 'Try It Free . . .'" pieces focus on the guarantee, a fairly common use for inserts. The hot pink "Rarely, can one cookbook . . ." lift letter addresses a specific category of reader (the mother/wife in this case). The simple black and white insert focuses on one of the desires of an aspiring novelist. The headline is a direct appeal to dreams of hitting it big. The design is perfect for the audience—black type on white paper. These headlines are powerful and noticeable—characteristics that summarize the attention-getting power of the design of these inserts.

Buckslips

Buckslips are usually designed as a single sheet of paper approximately the size of the envelope. Direct mail lore says they got their name because they're often the size of a dollar bill—a buck—and they're slipped in at the last minute. Buckslips are a good way to add information that increases the selling power of the mailing. They sometimes repeat the offer in a sort of visual shorthand. There's a powerful headline, short copy blocks, a quick summary of some aspect of the offer and often a visual—photo, illustration or clip art.

Sometimes buckslips focus on the free gift. Sometimes they focus on three or four major benefits. Sometimes they promote early response with some extra giveaway or incentive. Sometimes the design screams "This is a deal!" Buckslips are frequently printed on "cheaper" paper colors like the yellow, green, pink or blue papers offered at quick printers.

Think of the buckslip as a mini-flyer that is intended to flutter out of the envelope and draw attention to itself.

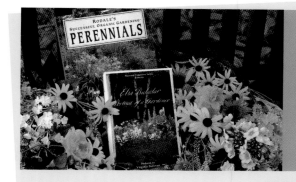

yours free!

This 40-minute perennial video has a retail value of $25.00. But it's yours to keep FREE—your gift for reviewing PERENNIALS, the remarkable flower gardening book from the experts at Rodale.

PERENNIALS
ALICE WILLIAMS, RODALE PRESS, INC.
This oversized buckslip plays up the **FREE** gift with a can't-miss reminder on every fold.

SECRETS THAT TRANSFORM YOUR GARDEN INTO A

gorgeous showcase

You'll discover . . .

PLANTING Plant a new perennial like this to be *sure* it flourishes. Best way to prepare the hole with compost. Every plant has a front and back—how to tell. What level to set the plant. Use your feet like this to straighten the root and firm the soil. Why you *never* water until you're done—and where *not* to water. Where to put the compost (and it's *not* on top).

DEADHEADING The secret reason why flowers bloom. Where to deadhead on the stem for an explosion of blooms. Why and how to use *both* hands to deadhead. When best to fertilize after deadheading. When and how best to add oxygen to the soil.

BORDER DESIGN Best way to start a new perennial garden. Which plants—and how many—to choose. Create the most eye-catching displays. Which mixtures of perennials work best. How close to space the plants. What to look for in a plant after the bloom has gone.

CREATING SPACE Make striking focal points and counterpoints with a few snips of your shears. When and how to cut back a growing plant—a quick check you must make to avoid a disaster.

STAKING When to stake a plant, and how best to do it. Which stakes to use, which to avoid, and why *never* to use string. Keep the display as natural as possible, by doing this. Secret way to tame unruly plants. What to do if a plant falls down.

This 40-minute video has a retail value of $25.00. But it's yours to keep FREE—your gift for reviewing PERENNIALS, the remarkable flower gardening book from the experts at Rodale.

Printed on 50% Recycled Paper 10% Post Consumer Waste

FIRST-AID FOR POT-GROWN PERENNIAL: Circled roots must be separated, so plant can take root and thrive in the ground.

UNIQUE WAY TO DEADHEAD multiplies your flowers and blooming season.

STAKING SECRETS ensure your plants are seen at their best all season long.

Printed in USA

DN23260C

Freemiums

A freemium is a free gift included in the envelope—like a bookmark, a bumper sticker, a booklet, a fold-out 3-D item or a poster. You get it just for opening the envelope!

The freemium is usually promoted on the outside envelope with phrases such as "Special Gift Inside" or "Free gift inside—absolutely no obligation."

It's good to stick with freemiums that do not raise postage. Since dimensional mail is not eligible for automation discounts, that means flat freemiums such as recipe cards, bumper stickers or bookmarks, not dimensional ones like free pens. Keep in mind the maximum weight of the package allowed by the USPS. As of this writing, Standard Mail A maximum is 3.3 ounces. For First Class, you pay a surcharge for each ounce over the first. Of course, it goes without saying that if a freemium increases response or profitability significantly, it could be dimensional, be as big as a house or weigh a ton. All it has to do is pass the cost-effectiveness test.

Vanna White Mailing
DAVID WISE,
WISE CREATIVE SERVICES, LTD.
Written and designed by David Wise, this craft project package contains a freemium—a crochet hook—that paid for itself in response and profitability. People are curious about "lumpy" envelopes, and eager to open them. You must check with the post office on the effect a freemium like this will have on the postage cost for the mailing. In general, lumpy packages do not qualify for automation discounts.

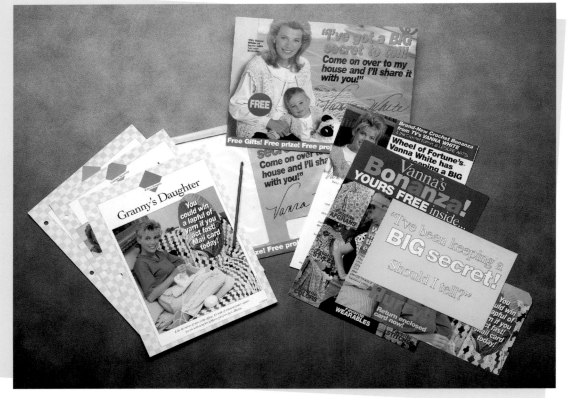

Tip-on Post-it Notes

3M now offers real Post-it Notes that can be preprinted and tipped on in production using automatic labeling equipment, which most printers have. They start at a minimum order of 10,000. (For more information, call 3M at 1-800-610-6942, ext. 10.)

Faux Post-it Notes (a yellow note graphic printed on a larger piece) have been used in direct mail designs to carry a headline or a kind of "last minute" selling thought. Obviously, they get attention and people recognize the format. The real thing gets even more attention!

Inserts: Should You or Shouldn't You?

There are no hard and fast rules about which type of insert to use or even whether to have an insert (or two) or not. You can't decide by classifying one type of insert as being only for upscale mailings and another only for downscale mailings or one type for business-to-business and another for consumer. Any of the inserts work for any type of mailing—you just have to design it to fit with the rest of the pitch, tone and concept. What you need to think about is what the insert does for the mailing psychologically. How will it help move the reader into becoming a responder?

Self-Mailers

or

Look Ma! No Envelope!

The definition of a self-mailer is pretty simple. If there's no envelope, and it's not a catalog, then it's a self-mailer.

Because self-mailers eliminate the envelope barrier, they start "selling" immediately. It's easy to tell if you're interested or not--all it takes is a quick look.

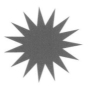

Self-mailers are primarily used for single product offerings that are pretty straightforward. You see them used for seminars and conferences, books, software, financial newsletters and less frequently for magazine subscriptions. They're used extensively in business-to-business for lead-generation mailings.

Self-mailers are cost-effective because they eliminate the envelope and insertion costs. You can even think of a postcard as a self-mailer—and you can't get much more cost-effective than that. Other familiar formats are seminar and conference brochures, folded and tabbed mailers that include magalogs (a combination magazine/catalog) and bookalogs (thick, maybe digest sized). Magazines often use the poster postcard (or posterboard) format—it's an 8½"x 11" flat card with the cover of the magazine, or some other immediately recognizable visual like a celebrity, along with an "envelope" reply card spot-glued on; the whole package is then wrapped in heat-shrink plastic.

Making a Self-Mailer Work

One way to think about how a self-mailer works is to realize that self-mailers offer the dynamite combination of the persuasive power of the letter, the information value of the brochure, plus the teaser copy of the envelope, often all on the cover.

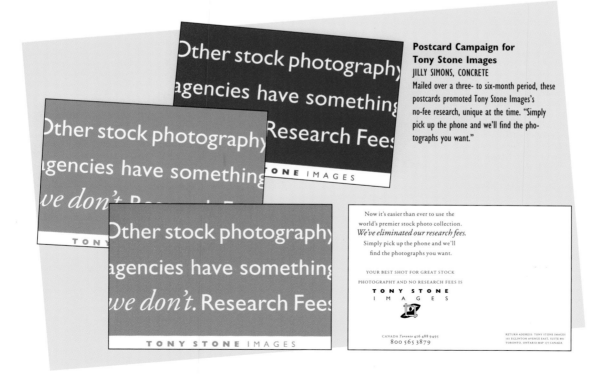

Postcard Campaign for Tony Stone Images
JILLY SIMONS, CONCRETE
Mailed over a three- to six-month period, these postcards promoted Tony Stone Images's no-fee research, unique at the time. "Simply pick up the phone and we'll find the photographs you want."

Watch people handle a self-mailer. They look at the front or the back first and then decide to read on or not. Then they probably check out their name. With these facts in mind, here are some overall design tips for the covers of self-mailers:

- Use the design to sell on both the front and back covers; if it's folded, design the piece to have an unfolding sales logic.

- Focus the reader on a powerful headline and subheads that can be easily read.

- Feature the benefits—list them, box them, make them jump out.

- Make the copy scannable—use bulleted lists, short paragraphs.

- Summarize the offer quickly—make sure it can be understood fast.

- For a dated event, feature the date on the front and back.

- Make anything free stand out.

Typical, Effective Copy Strategies for Self-Mailers

- News/Announcements— Introducing, Announcing

- Quick and Easy Remedies— 101 Ways to, The Secrets of . . .

- Valuable Information Inside— How to, Discover, Find Out, Learn

- Questions & Answers—Top Ten Most Frequently Asked Questions and Their Answers

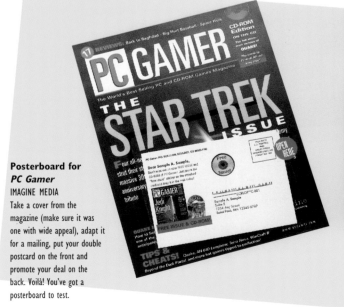

Posterboard for
PC Gamer
IMAGINE MEDIA
Take a cover from the magazine (make sure it was one with wide appeal), adapt it for a mailing, put your double postcard on the front and promote your deal on the back. Voilà! You've got a posterboard to test.

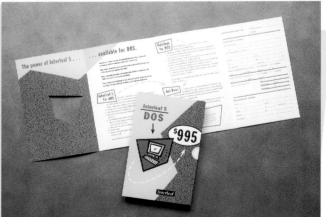

Interleaf 5 Mailing to Interleaf Owners
CLIFFORD STOLTZE, KYENG CHEE, DESIGNERS; JAMES KRAUS, ILLUSTRATIONS. STOLTZE DESIGN, INC.
Peek-a-boo! The die cut promotes opening and the arrows are great eye-flow devices. This mailing was directed to current owners of Interleaf software, so the price was the appeal and the symbolism was easy for this audience to understand.

- Use devices to pull readers inside the self-mailer—"See details inside," "Turn for more . . ."

Tell how to respond on every spread. It's not overkill. You can never predict exactly at what point a person will turn the corner and be ready to respond.

Extra Reasons to Love Self-Mailers

Self-mailers tend to get past "gatekeepers" and get delivered in businesses, probably because they are pretty nonthreatening (a quick and easy read) and

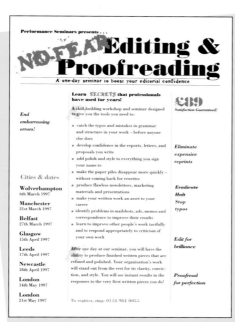

Seminar Mailing

MARY PRETZER, COMPACT DESIGN

Title. Price. Where. When. What. Copy that sells. Need more? See inside. This seminar mailing was a big winner.

"The 'No Fear' type font is Basketcase. Using it scared everybody before we mailed but I had confidence it would strike a chord with the audience. (In fact, it printed much more 'bloody' than I intended but it worked . . .) I used Bodoni to contrast with the Basketcase because it is a classic, conservative face that said 'Proofreading and Editing' to me."

could be offering something of value. Self-mailers for seminars, conferences, software updates, etc., don't seem to get classified as junk mail.

Self-mailers also have passalong value—people pass them along to others who might be interested. Bosses give them to subordinates. People pick them up off desks. Passalong can account for as much as 50 percent of the response.

Copy, Copy, Copy: Make It Easier to Read Than to Skip

Lots of self-mailers are copy-intensive, with an editorial flavor. They tend to be information-packed.

Design the inside spreads to capture your reader's interest quickly. People are not going to start reading at the upper left and work down the columns and then go to the next page. Their eyes are going to look for highlighted text, summaries of the copy, and other elements you emphasize graphically. Work with the copywriter to determine the best flow of the text and graphics. Look at the eye-flow and eye-path as the reader would.

Use sidebars to summarize information or benefits for the busy reader.

Use lots of headlines and subheads to hook the skimmer into becoming a reader of the longer body copy sections.

As the reader's eyes move through the self-mailer, the design should highlight:

- the offer, which the copywriter repeats several times in several ways (make it stand out differently each time);

- the guarantee (show there's no risk, point to the guarantee several times);

- the benefits (don't let the reader miss them); and

- the reply (make it easy to spot and easy to figure out).

The Letter Technique

Many multipage self-mailers also devote a page to a letter from someone associated with the product or service being sold. This faux-letter gives the self-mailer a more personal feel, at least on one page, and taps the selling power of a letter from a real person.

OHS MSDS Self-Mailer
MARK CHEUNG, CHEUNG/CROWELL DESIGN
Here's an example of a business-to-business lead-getting mailing promoting a CD-ROM-based product. It used the die-cut symbol of the CD to carry a very powerful message. "Flammable," "toxic," "corrosive," "reactive" and "hazardous" contrast with "new," a powerhouse direct mail word. Gold and blue were the company's corporate colors. The square format required extra postage but the client and the designers were confident the impact of the piece would be worth it. Turns out, it brought in more qualified leads than the company knew what to do with.

The Article Technique

Another powerful self-mailer technique is to design a copy block in the form of an article with a byline. This technique taps the credibility associated with a magazine or newspaper article.

The Testimonial Technique

Testimonials (those quotes of several sentences that say how wonderful the product or service is) are another staple of self-mailer copy. Sometimes they're sprinkled throughout the self-mailer. Sometimes they are organized together in a testimonial section. You and the copywriter have to work out what is more powerful.

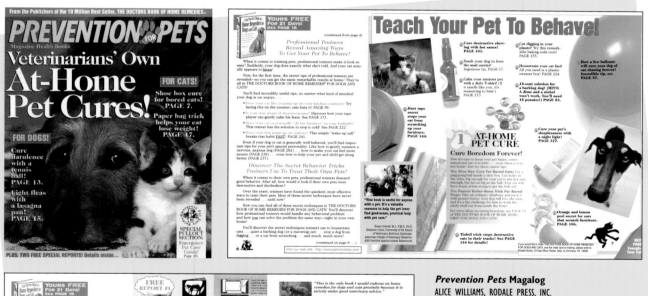

Prevention Pets Magalog
ALICE WILLIAMS, RODALE PRESS, INC.

"This was our first venture in the pet-care area, expanding our 'Doctors' Book of Home Remedies' brand into the pet world. The package won a Silver ECHO award from the Direct Mail Association. (It was also shown on the *Tonight Show*, where Jay Leno mentioned the 'cure flatulence with a tennis ball' blurb!)

"The design on this turned into almost a group effort with myself and another designer, Jeanette Powers, helping our Executive Creative Director, Mike Sincavage, get just the right warm-and-fuzzy appeal. It was the first time we were trying a magalog format where the order card was a gate-fold off the back cover. Our latest rollout of approximately six million pieces is proof that the client as well as our audience really went for the final version."

Design the Reply Form so Name, Address and Codes Come Back With It

Key codes printed along with the recipient's address are used to tell what list the name came from. Sometimes there's a customer code too. Mailers often want the returned response form to have those codes on them so they can track results by the source of the name. In these cases, you'll have to design the response device to capture the mailing address and the codes.

You can do this by putting the response form on the inside back cover if the outgoing address area is on the back cover. That way the address area comes back with the form. Or design the piece so the response device is on the back cover and carries the outgoing mailing address too.

In business-to-business direct mail, many responders prefer to fax back their reply. So you should make this an option and design the mailing to make it easy to fax back. The easiest way to do that is to design the piece with the reply form on the back. Of course, that reduces the area available for selling copy on the back cover. It's another choice that should be tested if possible. If you're offering the faxing option, it's especially important that your paper stock not be too dark, as it will slow down the faxing of the response form and may even cause the response to be illegible.

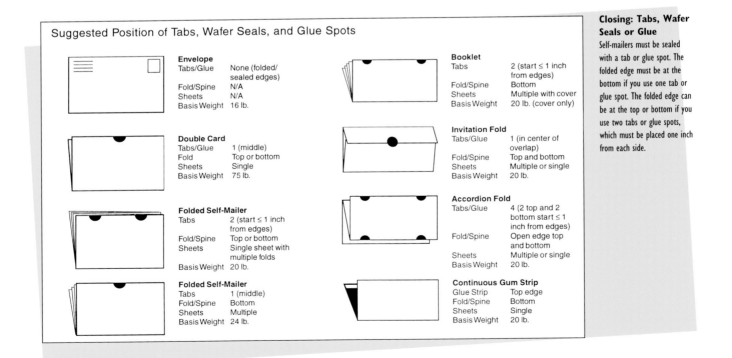

Suggested Position of Tabs, Wafer Seals, and Glue Spots

Envelope
Tabs/Glue	None (folded/sealed edges)
Fold/Spine	N/A
Sheets	N/A
Basis Weight	16 lb.

Double Card
Tabs/Glue	1 (middle)
Fold	Top or bottom
Sheets	Single
Basis Weight	75 lb.

Folded Self-Mailer
Tabs	2 (start ≤ 1 inch from edges)
Fold/Spine	Top or bottom
Sheets	Single sheet with multiple folds
Basis Weight	20 lb.

Folded Self-Mailer
Tabs	1 (middle)
Fold/Spine	Bottom
Sheets	Multiple
Basis Weight	24 lb.

Booklet
Tabs	2 (start ≤ 1 inch from edges)
Fold/Spine	Bottom
Sheets	Multiple with cover
Basis Weight	20 lb. (cover only)

Invitation Fold
Tabs/Glue	1 (in center of overlap)
Fold/Spine	Top and bottom
Sheets	Multiple or single
Basis Weight	20 lb.

Accordion Fold
Tabs/Glue	4 (2 top and 2 bottom start ≤ 1 inch from edges)
Fold/Spine	Open edge top and bottom
Sheets	Multiple or single
Basis Weight	20 lb.

Continuous Gum Strip
Glue Strip	Top edge
Fold/Spine	Bottom
Sheets	Single
Basis Weight	20 lb.

Closing: Tabs, Wafer Seals or Glue

Self-mailers must be sealed with a tab or glue spot. The folded edge must be at the bottom if you use one tab or glue spot. The folded edge can be at the top or bottom if you use two tabs or glue spots, which must be placed one inch from each side.

USPS Rules: Sizes, Folding, Tabbing and Addressing

To mail at letter rates by either First Class or Standard Mail and avoid paying extra postage, the self-mailer can't be bigger than 6⅛" x 11½".

To qualify for automation rates, folded or bound self-mailers must be closed with tabs, wafer seals, glue spots or glue strips. Self-mailers on 50# paper have to be tabbed or spot-glued closed with two tabs or spots one inch from each side. The folded edge can be at the top or the bottom.

Self-mailers on 60#-70# paper can be closed with one tab or glue spot if the folded edge is at the bottom. The folded edge can be at the top or bottom if the self-mailer is tabbed or spot-glued closed with two tabs or spots one inch from each side. The USPS prefers the folded edge at the bottom with the address parallel to the closed edge.

If the mailer has received special permission from the USPS, self-mailers may be sent at automation rates, even if not closed by one of these mechanisms.

If the piece exceeds 6⅛" x 11½" in one or both dimensions or does not meet aspect ratio rules for letter sized mail, folded or unfolded, it's categorized as a flat by the USPS and you pay more in postage. How much more depends on the rate of postage and to what degree the mailing can take advantage of presort and automation discounts. Here are some current differences in rates.

If you choose to mail flats, there will be an additional surcharge (per piece) over the regular postal rate. This surcharge rate is less if you presort, prebarcode, and mail a minimum number of pieces. Although your costs may seem insignificant per piece, they can really add up as you mail a thousand or more pieces. Contact your local post office for exact rates.

Given how many unfolded 8½" x 11" self-mailers arrive in the mail, it's easy to conclude that "flat" brings in more response and profit than folded for many offers. But again, it's one of those things to test. One seminar marketer recently used #10 white window envelopes with their self-mailer folded inside. The rest of the seminar business seems to be mailing flats. Test, test, test.

Note that most polywrapped mail is not automation-compatible. To get automation rates for polywrapped flats, both the mailer and the material have to be approved for automation rates by the USPS in writing.

First Class or Standard Mail

A self-mailer does not look like personal mail. It is what it is unabashedly. So, there's no reason to mail a self-mailer at First-Class rates other than possibly

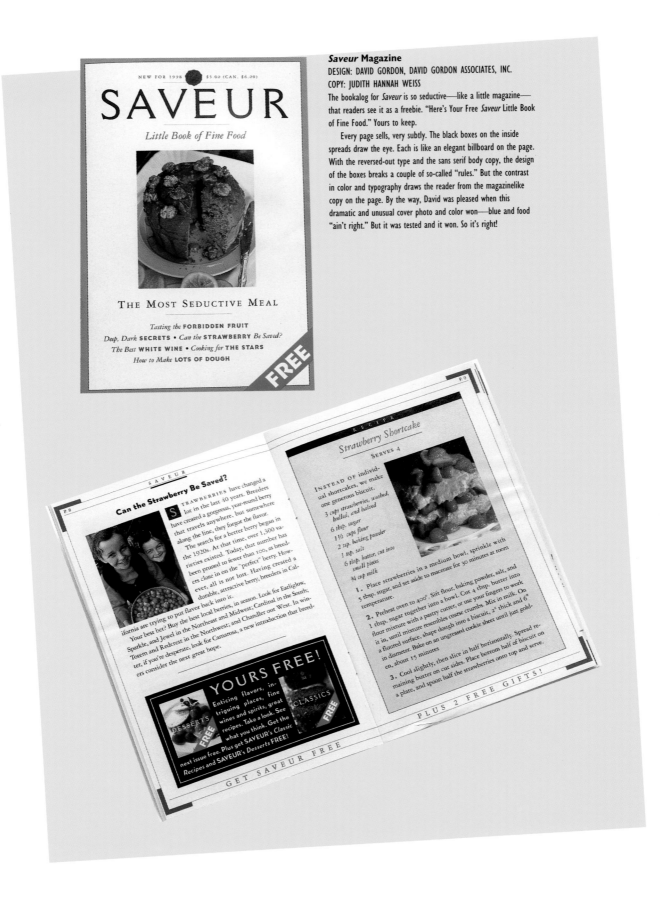

Saveur Magazine

DESIGN: DAVID GORDON, DAVID GORDON ASSOCIATES, INC.
COPY: JUDITH HANNAH WEISS

The bookalog for *Saveur* is so seductive—like a little magazine—that readers see it as a freebie. "Here's Your Free *Saveur* Little Book of Fine Food." Yours to keep.

Every page sells, very subtly. The black boxes on the inside spreads draw the eye. Each is like an elegant billboard on the page. With the reversed-out type and the sans serif body copy, the design of the boxes breaks a couple of so-called "rules." But the contrast in color and typography draws the reader from the magazinelike copy on the page. By the way, David was pleased when this dramatic and unusual cover photo and color won—blue and food "ain't right." But it was tested and it won. So it's right!

speed of delivery. And good planning should make that unnecessary. (Postcards mail at First Class because there is no rate advantage to mailing Standard. Double postcards, or postcards with a business reply card, mail at First-Class postcard presort rates.) If you have two hundred identical pieces to mail, use Standard Mail, since First Class doesn't buy you a thing with the recipient psychologically.

Meeting USPS regulations for preparing your self-mailer and trying to get automation discounts at whatever rate you mail at—profit or nonprofit, First Class or Standard—cuts postage costs substantially, and that money flows right to the bottom line. It really pays to be creative within USPS guidelines.

Do Your Own Droop Test

Put your mailpiece on a flat surface and extend it 5 inches over the edge unsupported. The edge opposite the folded or bound edge can't droop more than $1/8$ inch if the piece is $1/8$-inch thick or less. It can't droop more than $3/4$ inch if it's between $1/8$- and $3/4$-inch thick. Fail the test and your mailing doesn't qualify for automation discounts.

A Different Breed of Cat

The self-mailer is not a brochure with a mailing panel. It's really a different breed of cat. It's designed to get you from zero to sixty in terms of selling power in a few seconds. Its in-your-face style delivers more selling copy and visual appeal faster than the classic envelope mailing. That can be a plus or a minus. It depends on the product, the purpose and the audience. Again, observe your own mail. See what format is used for different types of offers and audiences. Learn from what's out there. Most people didn't think well-respected financial newsletters could be sold via magalogs or bookalogs to affluent, educated audiences. But testing proved them wrong. That's what direct mail is all about—finding out what works.

3-D or Oversized

or

When Can You Justify It?

Three-dimensional and oversized pieces get attention almost automatically. They stand out in the mail and the best demand interaction. Since three-dimensional and oversized pieces are also automatically more expensive to mail, designers often turn to them when the target audience is high-level decision makers (when a less high-impact mailing might never get past the secretary) or when the audience is very targeted and relatively small (fifty key accounts, one hundred top donors, ten leading surgeons).

How much can the client afford to spend to get an order or donation, generate a lead or build traffic? How much will the average customer/client/donor acquired by direct mail contribute to the bottom line? If you don't think about that relationship, we aren't talking "real" direct mail. Even if a client basically says, "I don't care how much it costs. I just want to get potential customers to attend the Knicks game and sit in our box," you're still taking the cost vs. response relationship into account. It's just that cost doesn't matter--only response and the long-term relationship does. Now those projects can be a lot of fun.

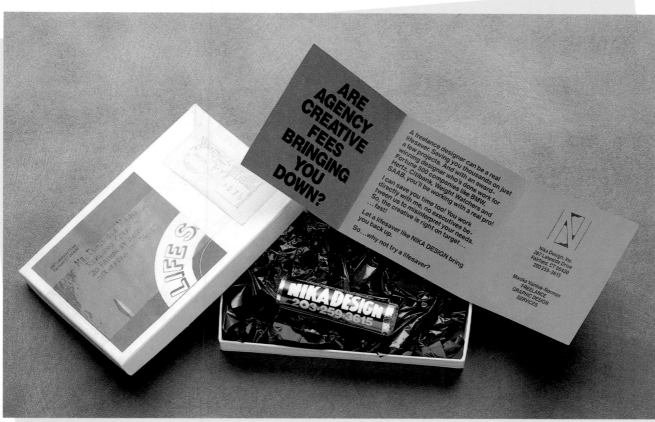

New Art Lifesaver Package
MONIKA VAINIUS, NIKA LLC

Nika LLC used this very successful 3-D mailing for several years. It was mailed to marketing executives in a specific geographic region, and it always brought in several very good new clients. The interesting thing was that even though the mailing promoted saving money and time by using a freelance graphic designer, it brought in clients who were impressed with the clever marketing and were not looking for a cut-rate solution.

Three Dimensions of Successful 3-D and Oversized Mailings

Three extremely important keys to the success of 3-D and oversized mailings often get overlooked. They are things to think about before the piece is ever presented to the client.

1. An offer, a call to action, a reply device (even a phone number) and urgency motivate response. To track if the mailing is successful or not, build in a response mechanism as well as a reason to respond—"Send for more information" or "Send for a free sample." Exciting graphics can't do the job all by themselves. If your objective is not to generate an immediate response but rather to create awareness, a mailing campaign is usually more effective than a one-time mailing. When you mail just once, there's a high probability that a percentage of your target audience just won't see the package no matter how impactful. People can be on vacation, out sick or just too busy.

2. It's critical to check with the post office before you get too far in the design process. Make sure your pieces will be mailable and then find out what the mailing cost will be. You don't want to be in the unenviable position of designing a mailing that can't be delivered.

3. To help ensure the success of your client's mailing, make sure the mailing list is up to date. For small-volume mailings, it can even be worth having someone call the potential recipients to make sure names and addresses are correct. Sometimes it's also a good idea to talk with your client to find out how well the audience is targeted. If you think they're not sending to the right people, let your client know—tactfully. Stress that a successful mailing depends on having the right list, even if it's limited to just ten people.

Using 3-D and Oversized for Self-Promotion

Mailing 3-D or oversized pieces for self-promotion has a dual purpose—getting response and demonstrating what you can do. The danger with self-promotion pieces is that they can easily get filed away among all the other interesting pieces your prospect is keeping for the day a project comes up. So again, it's key to build in a reason to respond and a way to respond. A reply device with copy that tells prospects how you are thinking about them and how you can meet their needs or solve their problems makes your mailing stand out. It can be that simple.

When It Works, It Works

The pieces you see in this chapter uniquely captured interest that translated into response. And that's the name of the game. While 3-D and oversized pieces have built-in power to attract, they are only successful when the calls come in, the reply cards get returned . . . and, ultimately, turn into profitable business.

Time Is of the Essence
DESIGN: JOHN SAYLES, SAYLES GRAPHIC DESIGN
COPY: WENDY LYONS
Sayles Graphic Design was originally contacted by J.C. Nichols Company in Kansas City to create a small quantity of four-color brochures to promote their upscale Plaza shopping center. "The cost per unit for such a small quantity was staggering," says the designer. "We knew there were other options." The spectacular hand-assembled clock with the message "Time Is of the Essence" made better use of the client's budget and made a far more dramatic statement.

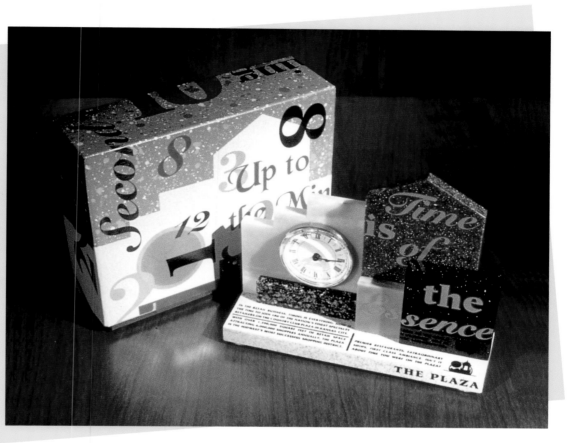

Hinge Promo
DESIGN: JILLY SIMONS, SUSAN CARLSON
AND DAVID SHIELDS, CONCRETE
COPY: DEBORAH BARRON
Hinge is a very successful recording studio. Clients range from
record companies to advertising studios. This promotion was geared
to make Hinge "top of mind" when choosing a studio. The
promotion was sent out to a short list of existing and prospective
clients.

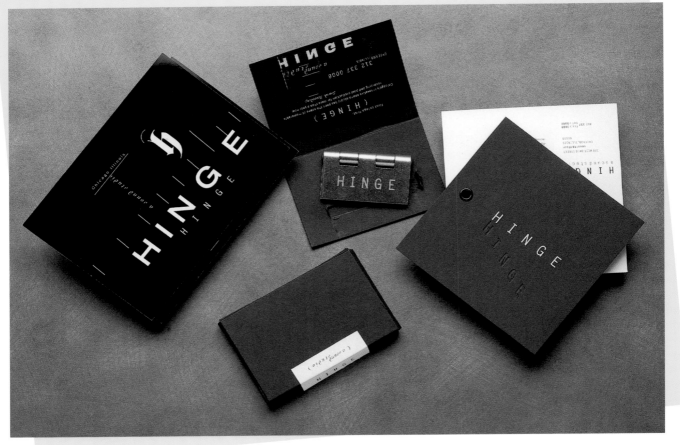

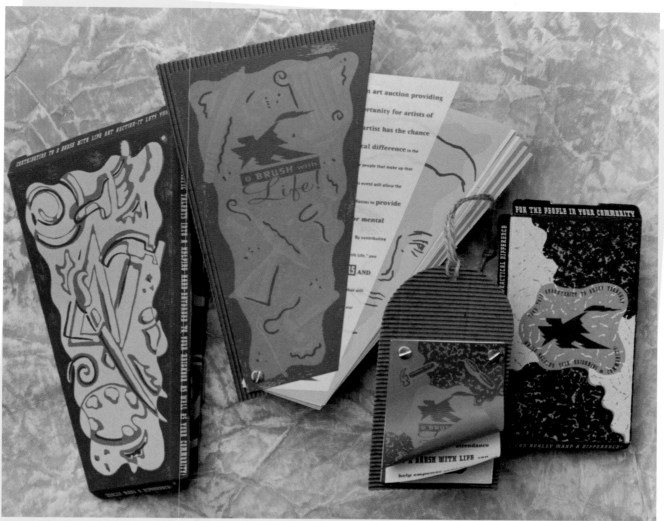

A Brush With Life

TRACY HOLDERMAN AND BRIAN MILLER,
LOVE PACKAGING GROUP

Brian Miller of Love Packaging Group has had great success with three-dimensional, corrugated packages. These pieces were done for The Mental Health Association's Art Auction, which was a huge success. Although it was only the first year for the auction, the event cleared over $15,000, more than double what the organizers expected. The mailing was targeted to artists and art buyers, and was assembled by volunteers.

A New Direction

To: Fibre Box Association Members From: Fibre Box Association Board of Directors

April 30 - May 1, 1995 · Four Seasons Hotel · Newport Beach, California

A new direction for the Fibre Box Association annual meeting. We're setting a new course and this is our declaration of renewal and revitalization of our annual membership meeting. This year's annual meeting will focus on the issues of developing and maximizing our human resources. You're invited to become a part of this new beginning. Truly to be a learning experience.

Please look for our promotion piece with actual program information, times and itinerary in the near future!

Fibre Box Association

Fibre Box Association Direct Mail Teaser
CHRIS WEST, DESIGN AND ILLUSTRATION; MITCH MCCULLOUGH, STRUCTURAL DESIGN. LOVE PACKAGING GROUP
This business-to-business direct mail announced the annual meeting for a private business organization. The meeting had been suffering from a decline in interest and participation. A mailing was needed to inspire the members to attend the function. Reservations poured in for the event and participation more than doubled over the previous year.

It's Big and Bold—GE Capital Assurance

JOHN HORNALL, ART DIRECTOR; JOHN HORNALL, LISA CERVANY, SUZANNE HADDON, DESIGNERS. HORNALL ANDERSON DESIGN WORKS

This highly successful promotion done for GE Capital Assurance, a provider of annuities and insurance, was targeted to a select group of brokerage general agencies (BGAs). The objective was to garner valuable BGA support by presenting the company as the premium financial services provider via breakthrough marketing materials that would communicate a service-oriented, innovative "personality", as well as leverage the reputation of the company's ultimate parent, General Electric. Presented in a printed box, the silk-screened acrylic plate introduces GE Capital Assurance's capabilities and focuses on the company's commitment to providing quality services and products. Centered in the piece is a clear acrylic cube that can be kept as a desk ornament or paper weight. The design of the cube used the GE logo and tied into the existing advertising campaign. The brochure surrounded the cube and incorporated aluminum fastener binding, textured paper stocks, exciting type treatments and creative embossing—elements that kept the recipient interested and involved in the main selling points.

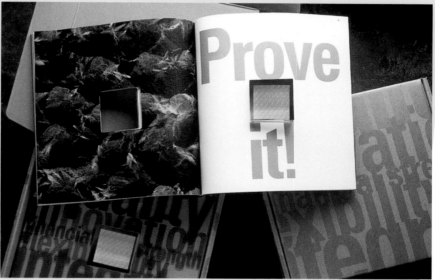

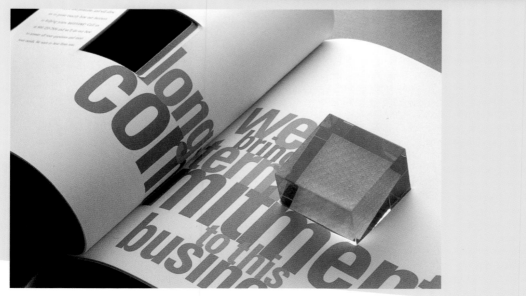

Says who?

GVO Five-Tiered Direct Mail Campaign
BILL CAHAN, ART DIRECTOR; BOB DINETZ AND KEVIN ROBERSON,
DESIGNERS. CAHAN & ASSOCIATES
"Our charge from GVO (an industrial design firm) was to create a
glossy, perfect-bound, thirty-two-page brochure with nice pictures of
their product designs to send to CEOs to get them interested in
GVO. . . . We decided to go beyond the brochure idea, and created
a five-tiered direct marketing campaign in the size of the *Wall
Street Journal*—a familiar size and medium to CEOs. Each week
they would get a different brochure delivered in a brightly colored
plastic bag with a different message on what it takes to create
breakthrough products."

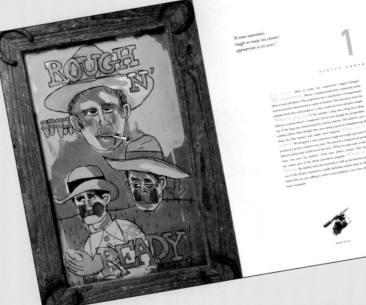

[closing thought] "When
I was a kid I used to read
a lot of science fiction. It
taught me that if you look
at the world in a different
way, you'll see things you
didn't know were there.
There is always another
reality right next door."

Michael Barry

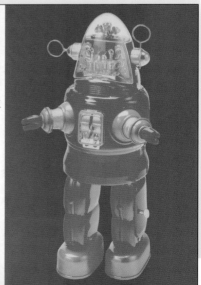

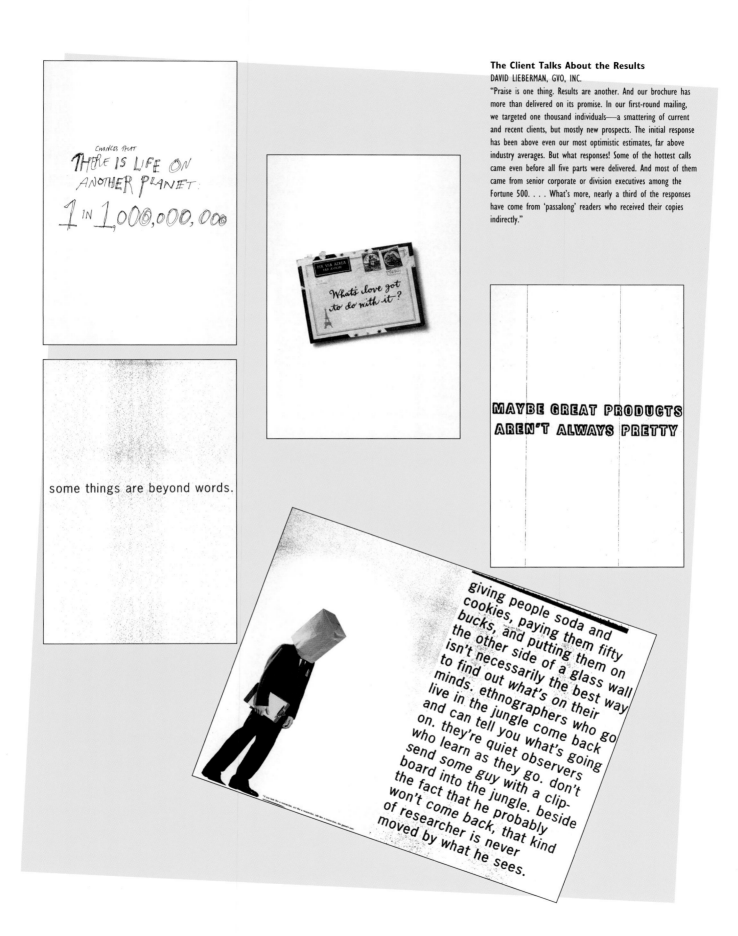

CHANCES THAT
THERE IS LIFE ON
ANOTHER PLANET:
1 IN 1,000,000,000

What's love got to do with it?

some things are beyond words.

MAYBE GREAT PRODUCTS
AREN'T ALWAYS PRETTY

giving people soda and cookies, paying them fifty bucks, and putting them on the other side of a glass wall isn't necessarily the best way to find out what's on their minds. ethnographers who go live in the jungle come back and can tell you what's going on. they're quiet observers who learn as they go. don't send some guy with a clipboard into the jungle. beside the fact that he probably won't come back, that kind of researcher is never moved by what he sees.

"Praise is one thing. Results are another. And our brochure has more than delivered on its promise. In our first-round mailing, we targeted one thousand individuals—a smattering of current and recent clients, but mostly new prospects. The initial response has been above even our most optimistic estimates, far above industry averages. But what responses! Some of the hottest calls came even before all five parts were delivered. And most of them came from senior corporate or division executives among the Fortune 500. . . . What's more, nearly a third of the responses have come from 'passalong' readers who received their copies indirectly."

Great Direct Mail Designers

or

Geniuses at Generating Response

I asked direct mail designers whose work is considered outstanding by direct mail professionals to contribute to this book. While I apologize to the many great direct mail designers I didn't have room to include, here you'll still find some of the biggest names in the business.

Each of these designers has created control package after control package. Each is a distinguished contributor to an ever-evolving field. Each is an innovator and a genius at generating response. And each has a lot to share with direct mail designers of any level of experience.

I asked the designers to submit work they liked, to talk about their work, about how they got started in direct mail, what they love about it, and what they think are the critical differences between direct mail and other advertising design.

As I interviewed these top direct mail designers, I was struck by the revelation that they share several characteristics:

- They love the challenge and competitiveness of direct mail. They love its measurability. They like winning.

- They are extremely empathic. Time and again, some phrase like "becoming the person" was used to describe the process.

- They are great marketers. Each direct mail assignment is like a puzzle, a game to figure out what approach combined with the copy and the offer will get the highest response.

- They are extremely articulate. They love language. They read the copy. Several write copy.

- They are extremely—and I mean extremely—interesting people. Lively. Opinionated. Talkative.

Creating this chapter was a great joy. I hope you appreciate the joie de vivre the following designers bring to their work.

Case Studies

The Design Half of Junk Mail's Top Dogs

HEIKKI RATALAHTI

Jayme, Ratalahti, Inc., Sonoma, California

Finnish-born designer Heikki Ratalahti is one of direct mail's foremost freelance designers. He and his partner, copywriter Bill Jayme, are legendary. At last count, they had launched thirty-seven magazines. Before their recent retirement, Jayme and Ratalahti commanded $20,000 to $40,000 per direct mail package, and in 1990 were profiled in the New York Times Magazine in an article entitled "Junk Mail's Top Dogs." Heikki's winning designs epitomize intelligent marketing and problem-solving. They are arresting, stylish, engaging and instantly recognizable as the work of a direct mail genius. These two partners get direct mail's highest accolade: They win—big!

Some of the publications launched by Jayme, Ratalahti, Inc.

Air & Space

American Health

Bon Appetit

Cooking Light

D, the Magazine of Dallas

Food & Wine

Harvard Medical School Health Letter

Home

Louis Rukeyser's Wall Street

Mother Jones

New York

Ohio

Psychology Today

Smithsonian

Tufts University Diet & Nutrition Letter

Worth

"Direct mail, it is said, is the most intimate of all advertising media. It is usually presented as one person writing to another.

"If that is indeed the case, then it has always seemed to me that components of a mailing package should bear a family resemblance, or at least an interconnectedness. To be successful they should more or less tell the same story in more or less the same way. They should also more or less look like they've met before."

"Anyone old enough to grasp a pencil should be able to draw a cloud in seconds. But here's a cloud that took me almost a full day to get right.

"Why? For one thing, postal regulations concerning the areas on envelopes that must be left blank. Plus the need to navigate around the die cut that lets the address show through. Plus the postal indicia. Plus the copy. But the chief stumbling block was that this isn't just any old cloud. It's a cloud that represents *The New Yorker*, whose unique graphics and typefaces instantly connote America's most sophisticated magazine.

"Along with my hand-lettering, the same major typeface is used throughout the package. The cloud reappears in the brochure. The copy and visual of the outer envelope lead inexorably to the opening of the letter.

"*The New Yorker*'s then-editor, the legendary William Shawn, called the Jayme, Ratalahti, Inc. package 'the first ever to truly capture the magazine.' It was the publication's control for several years until a new management took over."

"DID YOU SEE THE CARTOON
IN THE NEW YORKER
WHERE THE GUY SAYS TO HIS WIFE . . ."

A P.S. FROM EUSTACE TILLEY.

PLINK. SPLUT. KEPLOP.

This is the mailing package Ratalahti designed and Bill Jayme wrote to test market the concept of a member magazine, *Civilization*, for the Library of Congress. It later went on to launch the program.

"Inside the envelope there is the usual stuff. A letter. An acceptance form. A business reply envelope. But instead of a single brochure, there are three. All are 8½" x 11" folded down the middle. All are in full color. All have virtually identical formats with each numbered on the cover in the order in which they are to be read. Folder one. Folder two. Folder three.

"How come? Because the story of the Library, its new membership program and the magazine is one of the most complex I've ever had to communicate in design. If the average citizen is aware of the Library of Congress at all, he knows it as the world's largest collection of books. It is, of course, far more—an art museum, a research center, a lengthy stop on the Internet, a grade school, a college.

"The task of the first brochure is to tell the story of the Library, and to paint it as a highly desirable and prestigious institution to belong to and to support.

"The task of the second is to outline the benefits of joining early—like 'without delay'—so as to get in on the maximum number of exclusive Charter Benefits and Privileges.

"The task of the third and final folder is to whet the prospect's appetite for the member magazine, a hugely readable and engaging journal called *Civilization*.

"Breaking up this lengthy story into its three basic parts makes not only for easier reading, but also for quicker comprehension. It requires no more paper than a standard brochure. And where is it written that a brochure must always be on a single sheet that folds down smaller and smaller until it fits into the mailing envelope? It isn't."

"This package for *Commentary* magazine is one of the earliest direct mail assignments I took on after coming to New York from Helsinki in the late 1960s.

"The publication is a journal of informed opinion. At the time it cost $1 a copy. The offer was one of the first to enable a prospect to sample a complete issue at home without cost or obligation—heady stuff in those days.

"The outer envelope, like most effective carriers, appeals to the pocketbook. But at the same time, it also appeals to the mind—to the recipient's curiosity. Why 'sanity'?

"In designing it, I learned a basic lesson in direct mail design that has served me throughout my career. It is this: Simplicity, understatement and a feeling of order can often convey excitement more effectively than bells, whistles and starbursts."

Homegrown at Rodale

ALICE WILLIAMS

Rodale Press, Inc., Emmaus, Pennsylvania

Rodale is one of the most innovative direct mailers in the world. Every year Rodale, one of the country's largest publishers of health and fitness books, magazines and annuals, mails millions of pieces of direct mail and runs hundreds of tests. Alice Williams has been with Rodale more than fifteen years. When she started, there were only four designers; now there are seventy. Alice began by doing pasteup; now she's Creative Director, has created innumerable controls, and has won several prestigious ECHO awards from the Direct Mail Association. The Rodale creative team works for in-house clients (i.e., the magazines and books Rodale publishes) doing a diversity of direct mail design—packages, bind-ins, magalogs and bookalogs.

"The big differences between direct mail and other advertising design are:

- there's a lot more copy
- you have to have a response device
- there are a lot of rules
- there are a lot of constraints—the capabilities of the printer and inserter, sweepstakes rules, postal regulations, size of the order card in Canada vs. the U.S., etc."

"My advice to designers wanting to do direct mail:

- In direct mail, the focus is on the average real person. You have to appeal to that average person while doing good design.
- Keep it really simple—understandable to the customer in two seconds.
- Know the market, solve the marketing problem—and design for the customer, not for other designers."

"PICKING" JUST THE RIGHT IMAGES
RODALE'S SUCCESSFUL ORGANIC GARDENING

"I worked with a freelance copywriter, Richard Potter, on this project for a continuity series—*Rodale's Successful Organic Gardening.*

"We were running late on the copy side, so I ended up doing the layout and photo shoots in about a week. Being an avid perennial gardener myself, I had a good idea of the types of images that a gardener would respond to. Fortunately, my own first-year perennial garden provided all of the flowers used in the photos for the OSE [outside envelope], order card and premium stuffer. I cut them early in the morning, threw them into a cooler and drove to the shoot location.

"I think the use of a video premium was a good, 'upscale' choice for this audience. The simple beauty of the flowers, the simplicity of the package (a #14) and the great premium offer was a winning combination. The package was successful in giving the series a second 'standard' (a mailing that pulls high response)."

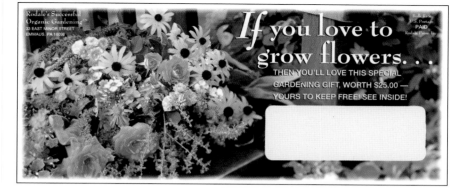

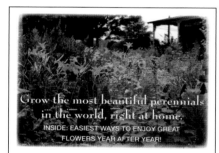

RODALE'S SUCCESSFUL ORGANIC GARDENING™

I'd like to send you a special video, filled with a lifetime of flower-gardening secrets, from one of America's most gifted gardeners.

It's a $25.00 value, but I want you to keep it, FREE—as our special "Thank You" gift.

Dear Fellow Gardener,

If you've ever longed to grow gorgeous perennials—to surround your home with nature's most beautiful and memorable flowers—here's wonderful news!

This is your chance to discover first-hand the easiest way to grow perfect perennials—and ... with a risk-free offer that brings you a remarkable gift to keep, FREE.

The gift is a special video with Elsa Bakalar, one of America's most celebrated perennial garden designers and teachers.

Create a masterpiece, in your own backyard ...

In her own jovial way, Elsa reveals tricks and shortcuts that help you quickly create a perennial masterpiece of your own. You'll discover secrets that, literally, took a lifetime to learn ...

- Absolute best way to start a new perennial garden.
- Quick pruning trick doubles—even triples—your blooms.
- Best way to stake a plant (why to <u>never</u> use string!).
- Expert cuts that instantly turn your garden into a gorgeous showcase.
- And many more—as many secrets as can be packed into forty minutes!

The video has a retail value of $25.00. But I want to send it to you FREE.

(over, please)

Grow the most beautiful perennials in the world, right at home.
INSIDE: EASIEST WAYS TO ENJOY GREAT FLOWERS YEAR AFTER YEAR!

Surround your home with a dazzling display of color and beauty!

RODALE'S EXPERTS MAKE IT QUICK & EASY

- Best times to plant for very best results. Page 47.
- **Instant squeeze-test** shows if your soil is too dry, too wet, or just right. Page 44.
- Simple move **destroys common site of disease** before it can start. Page 69.

4 designer tricks-of-the-trade help you find the perfect perennials for your garden. Page 33.

Start or expand your garden for *virtually no cost* with these amazing propagation techniques. Page 74.

- **Best way to water** without promoting weeds, disease or waste. Page 54.

Simple pre-planting move *guarantees* you a head-turning display all season long. Page 24.

- Organic miracle-worker—**best home-grown compost mix** from garden, yard and household wastes (though be sure to leave **this** out). Page 58.
- Chemical-free (and easy!) way to kill grass and make way for new garden bed. Just spread this and wait. Page 44.

Perennials that can bloom *twice* every season (if you do this at the right time). Page 63.

- **Super-smart planting trick** gives you extra flowers for indoor display **without** stealing prize blooms from your garden. Page 30.
- Best time to stake growing plants to guarantee a magnificent show later. (Simple calendar trick helps.) Page 60.

Buyer beware! Tell-tale tip-off that new plant is hiding pests. Page 37.

- When—and where—to pinch budding plants for best shape and show of flowers. Page 62.
- Farmer's secret recipe for liquid fertilizer that's quick-acting—and potent. Page 56.

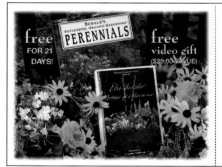

free FOR 21 DAYS!

PERENNIALS

free video gift ($25.00 VALUE)

free gift request card

yes! Rush my FREE *Portrait of a Gardener* video at once. Also, send PERENNIALS for 21 days FREE. If I choose to keep PERENNIALS, you will bill me according to the terms described in the letter. Of course, I'm not obligated to buy any books ever. And I may cancel anytime simply by notifying you. If I decide not to keep PERENNIALS, I'll return it within 21 days and no other books in Rodale's Successful Organic Gardening series will be sent. The perennials video is mine to keep no matter what.

CN32936

send no money—this is a free review & gift offer

The "Dive In" package was created for the launch of *Rodale's Scuba Diving* magazine. This is a very simple 6" x 9" package with all the direct mail basics included: the free sticker, the Charter Offer, the premium offer.

"I worked with our former copy director, Mark Johnson, on this project. The copy and offer were pretty straightforward and simple, so I wanted to try something a little different and eye-catching with the graphics. In addition to this concept, I presented the clients with a 'safer' concept—a full bleed photo of a person scuba diving. It took some convincing, but the clients agreed to take a chance and go with this funky, bold look.

"It was the biggest launch package ever for a Rodale Press magazine, with some lists responding at 11 percent! The icing on the cake was receiving the Gold ECHO award in the 'Direct Mail Consumer' category. And there was no silver award that year—that's how far ahead we were from the competing packages!"

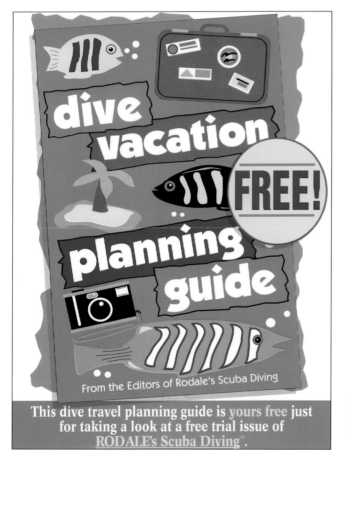

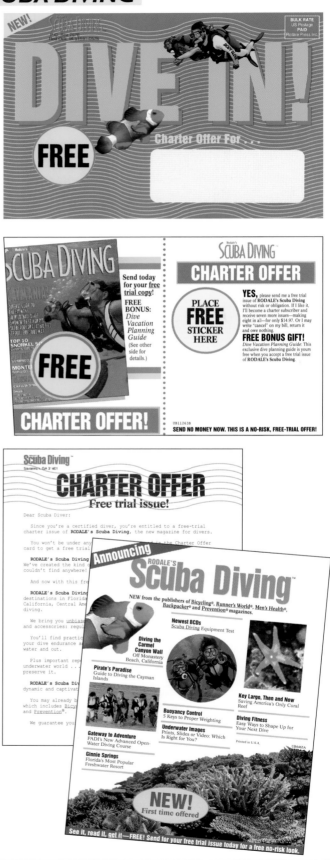

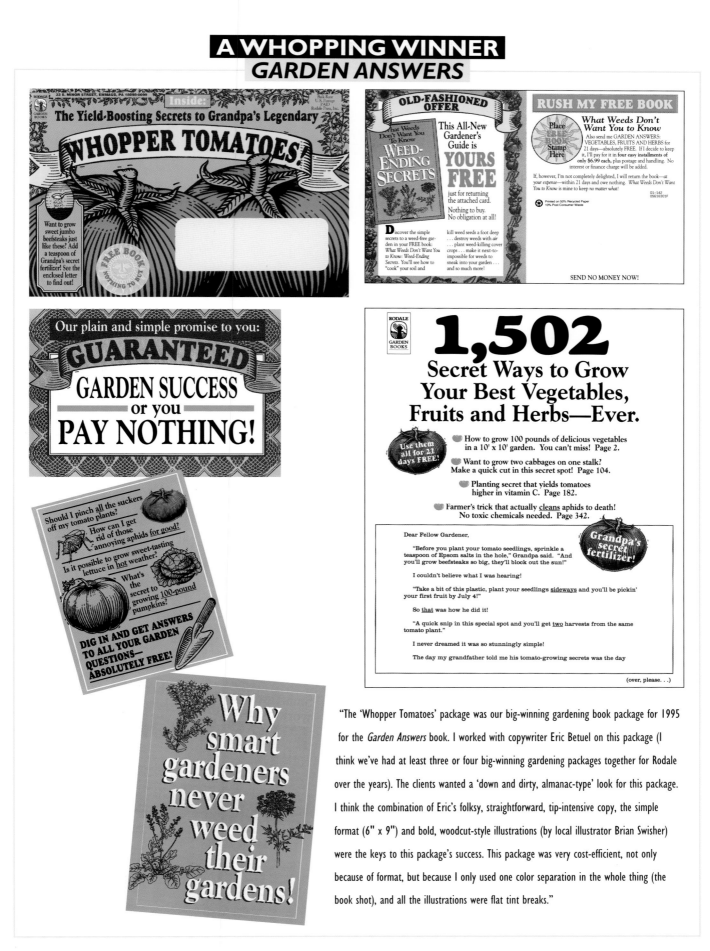

"The 'Whopper Tomatoes' package was our big-winning gardening book package for 1995 for the *Garden Answers* book. I worked with copywriter Eric Betuel on this package (I think we've had at least three or four big-winning gardening packages together for Rodale over the years). The clients wanted a 'down and dirty, almanac-type' look for this package. I think the combination of Eric's folksy, straightforward, tip-intensive copy, the simple format (6" x 9") and bold, woodcut-style illustrations (by local illustrator Brian Swisher) were the keys to this package's success. This package was very cost-efficient, not only because of format, but because I only used one color separation in the whole thing (the book shot), and all the illustrations were flat tint breaks."

A Believer in Beauty and Order—and Elegance, Above All!

RICHARD B. BROWNER

Richard Browner, Inc., Venice, California

A whole slew of the top names in the business have worked with—and admire—Richard Browner. Richard learned the ropes at American Heritage. There, he worked with Dick Benson and Chris Stagg, with whom he joined forces as part of Benson Stagg Associates, one of the foremost direct marketing consultancies of the 1960s. Of his direct mail designs, Richard says, "I believed that a visual tone-of-voice was as important as the writer's words. I believed in the logical tracking and 'build' of the copy, and made it happen always. I have always been a believer in beauty and order—and elegance, above all!" Richard's work is seminal, and you'll see the imagination and genius he brings to the genre in the examples here. His brochures in particular are inspiring.

"I receive a flood of direct mail and catalogs every week. The catalogs seem more targeted these days, both demographically and graphically, but the direct mail I see reflects little change visually from what came through the slot forty years ago. The aim is the same: Get the envelope open, no matter what nonsensical ruses it takes."

"I didn't so much dive knowingly into the sea of direct marketing as fall backwards into it."

"I have worked very closely with writers, and have never simply limited myself to laying out the copy that's been handed to me. The good writers always had a visual idea or two of their own, and were usually receptive to ideas that further dramatized their own. The indifferent writers seldom gave a damn what their packages looked like, as long as all the pieces fit into the envelope."

"Hank Burnett was a 'scholarly' direct mail writer. His copy was seldom frivolous and always long and detailed. But it was good copy, always. His choice of formats was typically conservative.

"One time, we were partnered on a package for *Texas Monthly* magazine. Sure enough, Hank's copy arrived along with his detailed rough: a 6" x 9" envelope and a four-page folder.

"His envelope phrase, 'How To Cut Texas Down To Size,' gave me an immediate idea for a graphic, a very unsubtle idea—a brightly colored map of Texas, cut off at both the top and bottom. Suddenly a 6" x 9" didn't seem the way to go. A #10 envelope seemed picayune so I opted for a #12, which had heft and space for display. It also meant a complete reformatting of the brochure.

"Since the length of Hank's headline for the front panel was just somewhat shorter than that of the Rio Grande, and since I had already reconfigured the folding of the brochure, I suggested breaking his headline down across several panels, thus leading the reader on a more interesting trip into the center fold.

"When I'd present changes to Hank, he'd always say, 'You're the designer'—an attitude of trust born out of years working together, and of total mutual respect."

"The challenge I faced when asked to design direct mail for the launch of this new magazine was that cross-country skiing didn't seem to be very photogenic (I searched through hundreds and hundreds of transparencies), unlike the excitement generated by shots of alpine skiers racing down slopes, hurtling off ledges and the like. Something would have to be done to make the photos more interesting.

"Herein lies one of the great excitements (for me) of direct mail design: brochure structure. Since there are only so many ways to fold paper, what could I do to create surprise and movement? All of the paper folds I created throughout my career were based on the sequential tracking of text and the visual excitement of a 'big finish' . . . some finishes, of course, being bigger than others.

"It had been determined in advance to mail in a 6" x 9" envelope. I decided to design a brochure which unfolded horizontally, using only parallel folds—horizontal as cross-country skiing. But to give it a breezier feel, all the visual elements—the columns of type, as well as the photos—were given a forward-leaning slant to create a sense of movement, and a warm, sunny yellow skier's stripe was used to offset the cool blue of the photography."

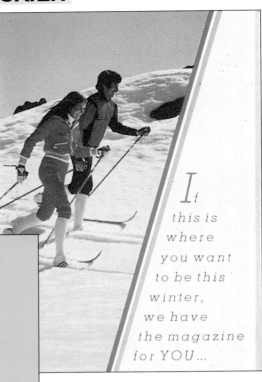

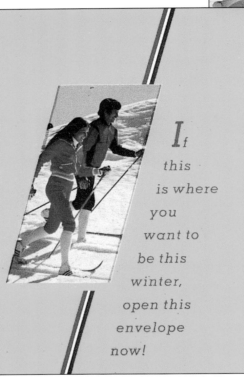

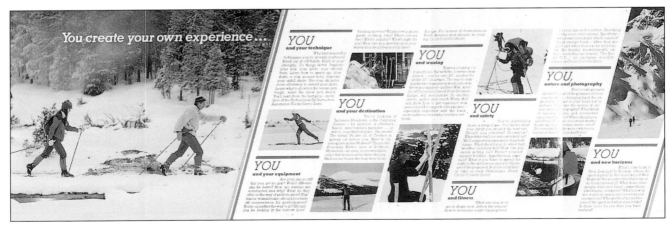

LESS COPY, GREAT ART
CAMERA ARTS

"*Camera Arts* was to be an up-market new photography magazine displaying the best in contemporary photography. It had to convey this message instantly, while at the same time announcing its 'newness.' The copywriter took care of 'new' pretty easily, and I decided to be both bold and reserved in the type treatment by printing the envelope in metallic silver.

"For the reverse side, I chose a demurely posed nude—passive, reserved, classical in posture. Not a hint of anything else. Since this was a brochure selling photography, and superb-quality photography at that, it was important to keep the overall brochure low-key, allowing the photos, and what little copy there was, to speak for themselves.

"There was to be a contrasting juxtaposition of images, black-and-white and color, and I chose not to overlap any of the photos, letting each stand out, as they might in a fine book or on a museum wall. Only the cover of the magazine was angled and, by use of bright red in its subject matter, separated itself from the rest of the photography with its muted colorations."

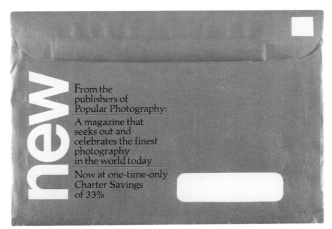

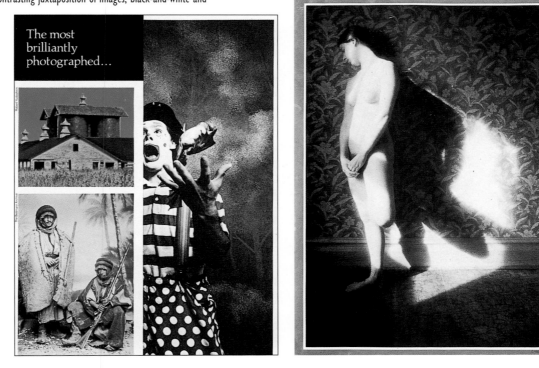

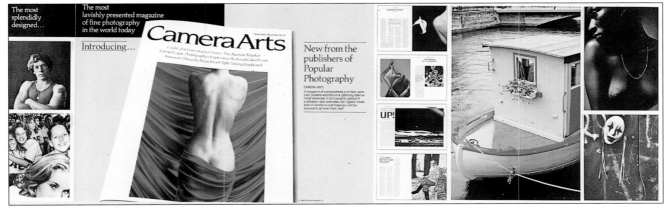

Queen of Poly Outers and L-Shaped Order Cards

NANCY DAVIS

Meredith Corporation, Des Moines, Iowa

Many of the Meredith Corporation's publications are among America's best-loved magazines, including Better Homes and Gardens, Ladies' Home Journal, Country Home, Traditional Home and Midwest Living. The creator of many of its direct mail "signatures"—including poly outer envelopes and L-shaped order cards—is Nancy Davis. Nancy has had a distinguished career at Meredith Corporation. She's been an innovator in direct mail and has designed more controls than you can count. She's hired the top freelance names in the business, too. Her job is to create winning packages and she excels at it.

"My career didn't start with direct mail design. Like most beginning designers, I simply took the first design job that was offered and considered myself lucky to have broken into the field. Seven or eight years and a couple of jobs later, I accepted a graphic design position in the circulation department at Look magazine in Des Moines. The year was 1964. I had absolutely no idea at the time that direct mail design was any different than any other kind of design, nor did I realize the impact that one decision would have on the rest of my life.

"What I did realize quickly, though, was that I had an aptitude for this discipline and an innate sense of how to handle copy. I loved the bold design, screaming headlines and loud bursts. I had a good teacher, few budget restraints and was able to utilize (for the times) some cutting-edge technology."

"The things I love most about this business are:

- the measurability—getting the response
- the competition—I love going head-to-head with other writer/designer teams in the same test, selling the same product
- the exclusivity—knowing you're among an unusually small group of direct mail designers who can produce winning packages
- the fact that you can fail with 95 to 97 percent of your customers and still be wildly successful. Just imagine what a hero you can be by producing a package that garners a double-digit response!"

"Our book group folks were doing handstands over the success of this one. They rolled with it a couple of years and even now still use the copy and format and update the photos (and copy where necessary) to reflect the new editions."

This package exudes warmth and the love of Christmas. The beautiful full-color brochure folds out to poster size with the headline designed to lead the reader from one panel to the next. The compliments in script at the top of each photo are the fantasy of everyone who tries to create a wonderful holiday for their family and friends. The personalized "free book" token is a classic Meredith involvement device to lift response.

And then there's the letter—it's soft and warm. And in just a few seconds, it personalizes the offer with the handwritten message, captures the heart of the Christmas lover with the angel dancing at the top, and leads you into the copy. Who cares if it's summer and 90 degrees outside?

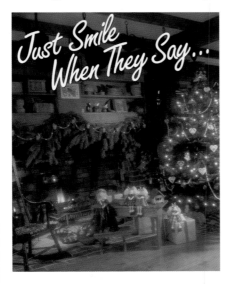

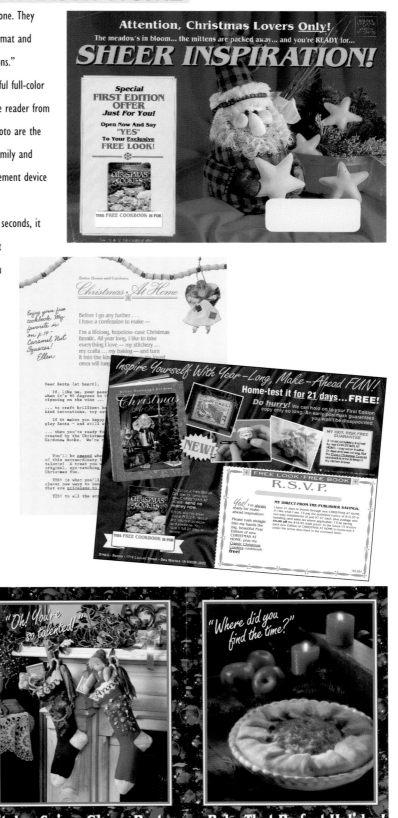

This package launched *Midwest Living* ten plus years ago. It looks like a travelog, sharing the love of the Midwest with its target audience through photos and serene colors. The photo borders in the brochure make the photos look as if they're from a family album.

Note that "Preview Issue" is visually emphasized in the die cut on the cover, the burst on the brochure, and on the token involvement device. A charter offer—being "the first"—tells the readers they're part of an exclusive, special group of people being let in on this wonderful opportunity. The message on the BRE—"Charter Subscriber Order Enclosed. Process promptly."—carries through the psychological appeal.

"Risk Free" is emphasized through a money-back guarantee box, the bold "Send No Money Now" head on the reply form, and from a burst that announces this offer is from the publishers of (the very reputable and well-known) *Better Homes and Gardens.*

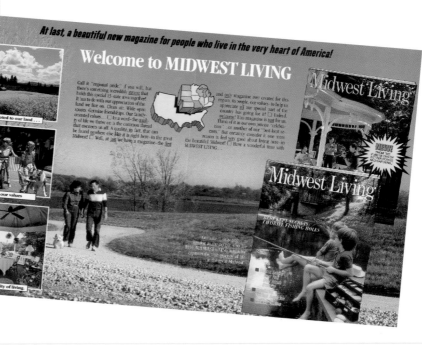

CREATING A WARM FEELING
AMERICAN PATCHWORK & QUILTING

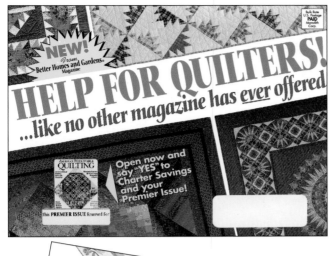

This package was another wildly successful launch, pulling a double-digit response. Quilts, quilts, quilts . . . quilts for beginners, intermediates and experts. This package combines practical appeal (help for quilters available nowhere else) with a strong tug at the heart.

Each piece in this mailing works on several psychological levels through the headline typefaces, the cropping of the photography, and the little messages in boxes or in handwritten margin notes. Working together on almost every surface are nostalgia, self-discovery, excellent instruction—plus "a free premier issue of a new publication." The Americana look of the lift note sets off the strong emotional headline. The main letter leads with a photo that points into the copy. The brochure shows not just quilts but an entire narrative, a story readers can project themselves into. The words and the images work beautifully with one another to produce outstanding response.

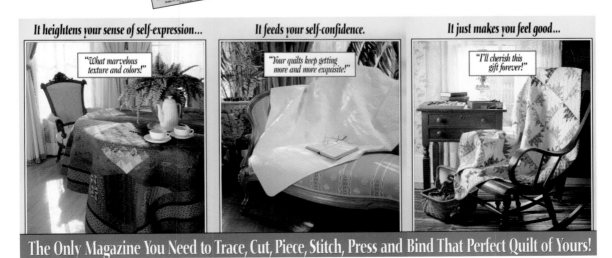

Maestro of Surprise and Delight

DAVID GORDON

David Gordon Associates, Inc., New York, New York

David Gordon designs packages that surprise and delight the reader. The word that best describes his packages is "classy." They are just plain seductive—and best of all, they are winners in copy tests. David started in direct mail as Art Director at Direct Mail Markets, Inc. It was the sixties, postage was cheaper and there were fewer postal regulations, and Direct Mail Markets was able to do a good deal of experimenting. The group turned out a package every week or two, doing a lot of great work, including the package for the General Foods Cookbook promotion (the largest cookbook promotion ever), the first continuity series, and the beginning of the concept of collectibles. Today, Gordon's clients benefit from a master's touch.

Three Direct Mail Principles From David Gordon

- Outers are critical—they're the one element worth testing. "If you can get 'em to open the envelope, you got your foot in the door." The right outer can make the difference between so-so results and a big winner.
- Move the reader to respond—get the message across clearly and quickly. Don't promote lingering over any element to the detriment of getting the customer to the order form. Always look at your work as if you are seeing it for the first time—and ask yourself, "Do I understand what I am reading/seeing? Do I get it?" If you don't, it's likely the audience won't either.
- Readability is paramount—direct mail is a reader's medium. Good design means that the message is easily read and understood.

How Did He Get Into Direct Mail?

He was trained as a fine artist. After several other jobs, he was hired as a messenger in an advertising agency where they noticed he could comp and draw. So they started using him, appreciating what he could do. When the agency closed down in 1959, they helped him get a job down the hall at Direct Mail Markets, Inc., where he discovered he had a talent for direct mail. In 1962, he went freelance and never looked back!

Gordon did the launch package for *Martha Stewart Living* and has been doing packages for Martha Stewart ever since. He does seasonal packages for the magazine—this is the winter control, written by Judith Hannah Weiss.

When he first designed these packages, Gordon designed the envelope to present vertically even though it costs more in postage. It just felt right to him. It's been tested against a 6" x 9" horizontal as well as other formats, and it's still the control.

The package is very classy. It's got a beautiful look and feel with elegant typography and great photos. The photos were selected with balance, color and focus in mind. The colors in the package on the lift letter and the response card were carefully selected to project the feeling of the magazine. The brochure contains very little copy—it's a feast for the eyes. The package employs loads of classic direct mail tricks of the trade: an RSVP token, a freemium plus a free gift, an L-shaped reply card and a lift letter. But what it does best of all is capture the distinctive character and promise of the magazine.

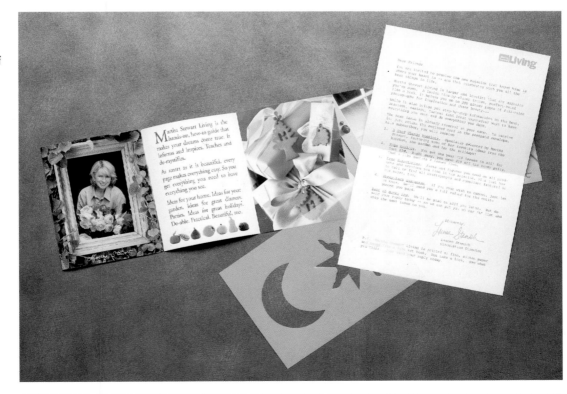

package because the disparate ...lope surprise and delight. And the brochure carries on that sensation with the play of images and the contrasts of time and space.

In this package, the envelope and the brochure really work together. Gordon loves working with collage, and the brochure uses overlapping imagery and contrast to pull the reader along with a new wonder at every turn. The package is "jazzy,"—like Judith Hannah Weiss's copy. It feels wonderful and informative, like the magazine. As the reply card says, "Glossy, exciting, inviting, enticing, absolutely one-of-a-kind."

Our favorite
four-letter word...

*"You don't have to be
a scientist..."*

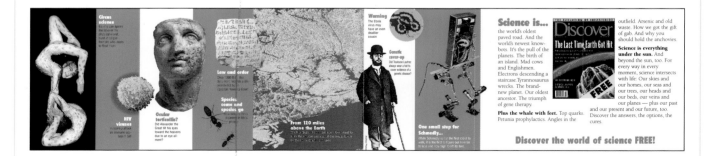

Sex sells—it sure does in this package. "Come for the sizzle and stay for the smarts." The envelope is almost demure, but the typography cuts to the chase, so to speak, with "naked with Sharon Stone" leading right into the window. The slim and very sexy brochure certainly raises the testosterone level.

Gordon likes the contrast between the elements. The lift letter is an elegant rendition of the benefits list. The reply card is strikingly different. It emphasizes the offer, not the sex. The outer and reply card are "cool" visually while everything else in the package (created with copywriter Judith Hannah Weiss) is hot. Like the letter says, *Esquire* is 100 percent—unabashedly—male. And this package makes sure you know it.

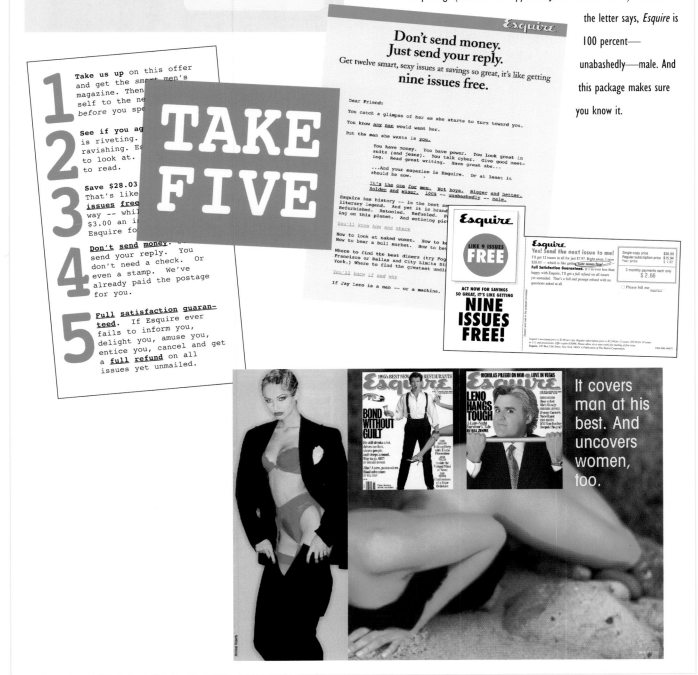

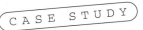

Creative Chameleon

JYL FERRIS

Ferris & Company, Easton, Connecticut

Jyl Ferris is a freelance designer who has worked in direct response for almost twenty years. From her studio in Easton, Connecticut, she designs direct mail packages that win, but she especially loves to design beautiful direct mail packages that win. She's passionate about everything she does and offers her talents pro bono to many nonprofit causes. Jyl believes that to do great direct mail, you have to be a creative chameleon—able to take on the persona of your readers and see the world as they do—and change with every assignment.

"What I love about direct mail design is the challenge of combining the art of design with the art of good direct response. There are certain elements that must be contained in a direct response promotion. The instructions, the bursts, the callout type, which can all be regarded as a hindrance to a good design, must instead be looked at as a design challenge. How can I make this burst help my design? How can I make the reader understand the offer? Entice them to buy it? And make it easy to reply?"

"The difference between direct mail design and other advertising design is that direct mail asks the reader to make a decision immediately. The offer must be apparent. You can't just create a feeling or an atmosphere as in advertising design. All the questions must be anticipated and answered."

Tips From Jyl

- Listen to your clients carefully and research the product. Who is the target audience? What is the competition? What promotions have worked before? Which have failed? Study the product to get into the head of the prospect. Notice the colors, style and language of the product.

- Make the offer clear.

- Try to organize forms so anyone can follow them. (And leave enough space for people to write their names!)

SOMETHING DIFFERENT
nest

The *nest* launch package was designed to reflect a unique new interior design magazine. From the extraordinary envelope flap to the unusual brochure fold, the package declares the magazine is something out of the ordinary. Even the letter has a little unusual touch—the rounded upper right corner.

The brochure's unusual fold introduces a tactile element. It invites handling while showcasing the magazine in a "show off" format. Copywriter Ruth Sheldon and Ferris wanted every element to give a bravura performance.

Note, however, the direct mail principles in action—the letter typeface is Courier, FREE stands out all over the place, and there's an exclusive invitation. Same old tricks of the trade in a classy package that captures the "soul" of the magazine. The package is both beautiful and a winner.

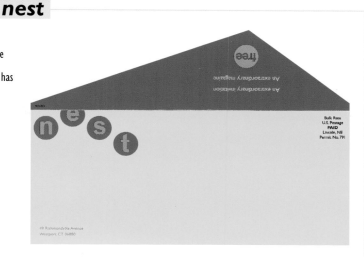

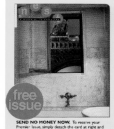

The "Yes, you can!" package design exuberantly supports the promise that everyone can create a dream home. Easily. With "money to spare." With style and flair. The warm colors invite. The small, repeating design elements throughout the package elements project heavenly magic. In the simple, elegant french-fold brochure, the perspective of many of the shots lures the viewer into the dream.

The package echoes the feel of the magazine. Ferris and copywriter Ruth Sheldon read a year's worth of the magazine—the ads as well as the copy—to get inside the head of the reader. The design then emphasizes the buzz words and the imagery that Ferris knows drive the reader to respond. Combining the art of design with the art of good direct response is the ultimate challenge.

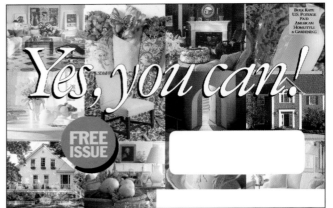

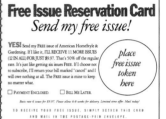

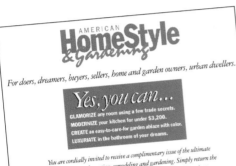

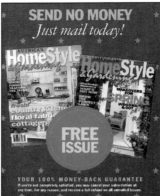

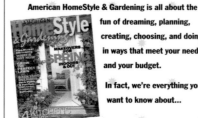

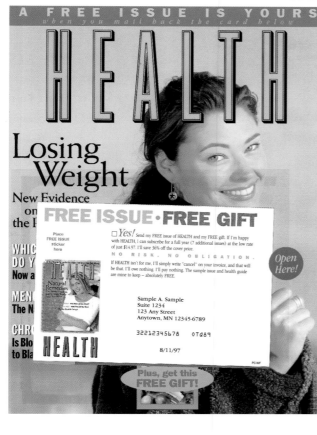

The original assignment was to redesign the control package for *Health*—and the posterboard version evolved out of the redesign. The brochure, the posterboard, the response card all use a palette of strong, fresh colors to project the image of the magazine and to move the reader to response.

Everyone felt the appeal of the front cover of the brochure could be capitalized on to create an alternative control. The posterboard mimics the cover of the magazine with the "Free Issue" skyline and a run of coverlines down the left side.

The rest of the 9" x 12" package (not shown) includes the freemium of three Health Information Cards—easily found because of the paper stock and color. The letter inserts testimonials in bright swatches, each of which repeats the line "read from cover to cover." The six-page brochure creates a quick, bright, healthy-looking bonanza of health tips, and ends with a roundup of the benefits and the directive to respond.

CASE STUDY

"I Am the Audience"

DAVID WISE

Wise Creative Services, Ltd., Charlotte, Vermont

David Wise not only designs winning direct mail, he writes it. From his studio in Vermont, he's designed direct response packages, ads and inserts for the likes of Playboy, Saveur, Wired, Meredith Corporation, Rodale, Time Warner, Weight Watchers, Martha Stewart Living Books, Utne Reader, BYTE and many, many more. He's had a remarkable career, worked with the best writers in the business and he's really wise in the ways of direct mail. If you ask him to sum up what works in direct response, he says, "It's the customer, stupid!" The key for him is getting inside his audience's skin, play-acting the part of the customer.

"Once a client told me not to use pink. But when I was being the customer, I looked out and saw pink everywhere, because I was being a 65-plus woman concerned about health problems. Pink comforted me, made me feel safe. And pink was all over my imaginary living room. So I designed with lots of pink, fought for pink with the client and won. The promotion went on to become their most successful direct response ever.

"Was pink the key to success? Absolutely not. The product benefits, the copy, the design and the list selection were all near ideal. But pink did not prevent the promotion from being successful. On the other hand, blue or red just might have!

"So if I have a rule, it is this: Keep your eyes open, keep your ears open, absorb everything you can about a product and its audiences. Then forget it all and see what happens in you. Good (successful) direct response design emerges. It is informed—but not controlled—by the rules, whatever they may be. Enormous promotional breakthroughs usually step on the toes of one or two conventions! But if I did not know the rules—experientially—then I would not know which to follow and which to ignore or tweak!"

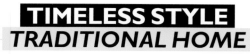

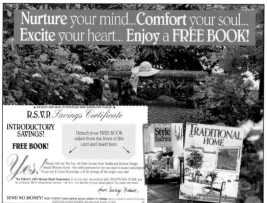

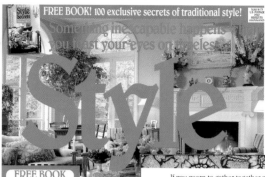

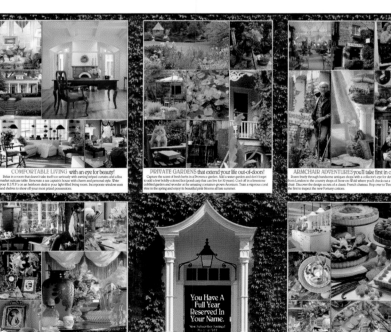

Written and designed by Wise, this control package taps into the dream, the fantasy, with compelling immediacy. It's delivered in a poly bag. Wise says that poly outers are like looking into a picture window—they're the outside and the inside at the same time. But if you want what you see, you have to go inside.

The rich, warm color of this package projects a comfort zone of "timeless style." Every image encountered is designed to take you into the special world of *Traditional Home*, from the William Morris-style border on the letter to the enticing world that unfolds as you open the brochure. Wise has found that with lifestyle audiences, more is more. Many smaller photos cropped carefully and arranged artfully work better than a few large interior shots.

The "free book for" token on the cover is designed to raise response. It intrudes into the lovely living room deliberately.

Sex sells, even in the animal kingdom. In this package, copywriter Shelly Gentile and Wise educate and titillate at the same time. Who wouldn't pull down the window to see that proud mother's secret?

Secrets, primal instincts—this package was designed to be hot! Bright red heads in the letter lead the reader into the little vignettes. Bright yellow, hot reds, pulsing purples are everywhere in the package. Emotion carries the reader through the brochure—"Killed, Destroyed, Decapitated"—then as the brochure unfolds, "Conquest, Courtship, Conspiracy, Competition" get hotter with their red-orange, bright-yellow-shadow type treatment. The reader should be sweating by now.

The idea here is to tap the prurient interest of the person fascinated by nature and animal behavior. And it's easy to order, there's no risk. The high excitement motivated high response despite the fact that the only thing free the reader is getting here is a ten-day free preview. *That's* getting into the customer's skin.

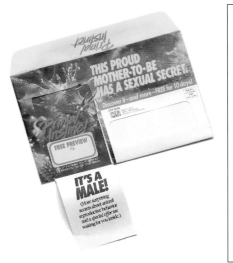

Two tiny seahorses float together in a delicate underwater embrace. In the age-old tradition, one gives. The other receives. But there's a twist. Fifty days later, it's the *father* who gives birth.

How could a male get pregnant?

A female rhesus monkey slips beyond the watchful gaze of the troop's dominant male for a sexual encounter with a newcomer. If caught, *she knows* she will be severely punished.

Why does she take the risk?

During breeding season, a male bower bird painstakingly constructs an archway of slender twigs, then strews a path to it with bits of blue paper, flower petals and plastic.

What could it possibly be?

Dear Viewer,

Welcome to the secret side of animal behavior. A side so hidden, few people ever get to see it. So mysterious, we are only beginning to understand it. And yet so basic, it ranks as the most powerful force in nature.

Some call it the instinct for survival. Others think of it as the urge to continue the bloodline. But whatever name you give it, the drive to reproduce triggers some of the most fascinating, bizarre behavior in the animal world.

Behavior you can witness now -- for the first time -- in the breakthrough new TIME-LIFE VIDEO series, PRIMAL INSTINCT.

Get your first glimpse when you preview The Secret of Survival for 10 days FREE!

Until now, TV documentaries have shied away from showing you the true nature of animal sexual behavior in the wild. And for good

(over, please)

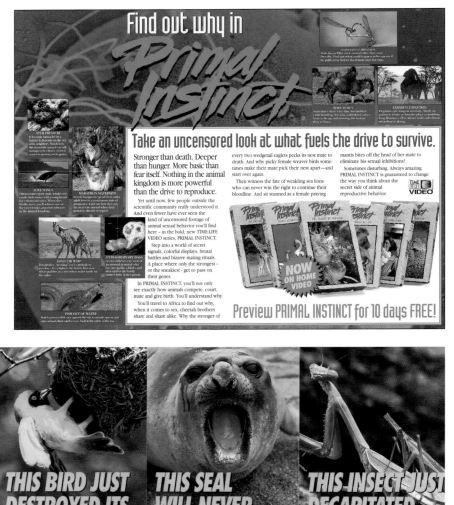

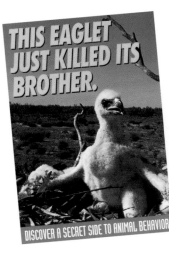

DISCOVER A SECRET SIDE TO ANIMAL BEHAVIOR

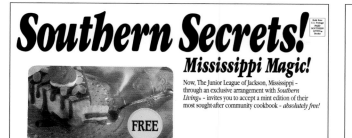

Southern Secrets!

Mississippi Magic!

Now, The Junior League of Jackson, Mississippi - through an exclusive arrangement with *Southern Living* - invites you to accept a mint edition of their most sought-after community cookbook - *absolutely free!*

FREE

Try Mrs. Goodman's Chocolate Rum Angel tonight! Free recipe inside!

Bulk Rate
U.S. Postage
PAID
SOUTHERN
LIVING
Books

The SOUTHERN LIVING®
Community Cookbook
HALL OF FAME

Now, you can own this exclusive collection of tried-and-true community cookbooks - some out of print and hard to find - thanks to a special arrangement with *Southern Living!*

I'll send you one *free* to keep forever, and another to try *free* for 30 days! Here's all you do...

Dear Friend:

Could you use a few free recipes? Not just one or two. In fact not just fifty or sixty!

Could you use <u>over 950 fantastic recipes</u> -- absolutely <u>FREE</u>!

Good, because I've reserved a copy of one of the South's most sought-after community cookbooks <u>in your name</u> -- and I'd like to send it to you <u>FREE</u>! Gratis! With no purchase required of any kind!

<u>Simply return the FREE RECIPES INVITATION CARD enclosed, and I'll send you SOUTHERN SIDEBOARDS in return. Yours to keep forever</u>!

It's the out-of-this world community cookbook compiled by The Junior League of Jackson, Mississippi. And, unless you visit Jackson, Mississippi -- or know someone who lives there -- you may not be able to get a copy of this invaluable cookbook.

Unless you know someone at <u>SOUTHERN LIVING</u> Books -- like me! You see, we've made special arrangements with the Junior League of

over please ...

FREE!

The wonder of
Great Grandmother Doty's
Sugar Cookies, **PAGE 287**

Now, generations of
COOKING SECRETS!
Passed down
to you!

Free 'n Easy!

FREE!

The secret to Old
McDonald's Oven-Barbecued
Chicken, **PAGE 180**

FREE!

The secret of
Mrs. Bracy's Old-Fashioned
Shortcake, **PAGE 324**

FREE!

The pride of Old LeFleur's
Restaurant: Chicken
Jambalaya, **PAGE 188**

FREE!

The magic of
Aunt Ruby's Hot
Apple Fritters, **PAGE 368**

While the offer is for a continuity series of cookbooks, the outer strategically simplifies matters by only promoting the free cookbook and the free recipe inside. Copywriter Ken Schneider and Wise are concentrating on getting that first response.

The big picture window holds a mouth-watering photo of a homey "Mississippi" dessert accompanied by a peel-off "FREE" sticker. If you can't quite make up your mind about Mrs. Goodman's dessert, that "FREE" helps you decide to at least look inside the envelope. Note the die cut on the response card and the big perf marks—they signal what to do. The tall brochure is designed to stand out in the package. Each panel depicts a "Southern" dish in a tightly cropped shot heralded by a big, red, bold "Free!" In the main brochure and flyer, every recipe or secret promised is accompanied by a page number—how can you go wrong?

The secret of this package is triggering our desire for those great dishes people who had time to cook used to make—you know, from those cookbooks with secret family recipes . . . yum! Every piece in this package tells you it's "Free 'n' Easy" to get the gift, the preview of the first cookbook and generations of cooking secrets.

Reading Rules

TED KIKOLER

Ted Kikoler Design, Toronto, Ontario

Toronto-based direct mail designer and writer Ted Kikoler's reputation was made when his first package (a newsletter offer) pulled 33 percent greater response than the control. Even better, cash-with-order was up 100 percent with his package. At the time, Ted was a freelance designer doing mostly retail advertising. But a newsletter client asked him to do the final art for new creative to test against the control. Ted loved the copy, but not the design. It just felt wrong. So wrong, in fact, that Ted offered to design a test package himself—for free. The client agreed on the condition that copy, the offer and mailing costs stayed the same as the control. The client actually hated Ted's package when he saw it, but in the end mailed it. And it won big. The rest is history. Today Kikoler commands top dollar and respect—and has a long, long client list.

"The sole purpose of design in direct mail is to get people to read the copy. The longer you can keep a person reading, the higher the response will be."

Mr. Sample

Kikoler's working method is to become Mr. or Ms. Sample, to immerse himself in their world, to ask himself: Who am I? What do I want? What do I fear? "I see one person," he says. "As I forget myself completely and become that person, I see the type, I see the color, I know what turns him or her on and off emotionally."

The Human Touch

Kikoler believes that many of the best direct mail packages come across as a one-on-one conversation, with graphics toned down to a whisper instead of a shout. Simple serif typefaces. The letter in Courier or Prestige only. He wants his packages to feel like they came from a live human being, not a machine. "When you give the reader the feeling that the letter was written by a real human, the order form was filled out by someone in the office, the components were folded and inserted by hand, you stand a greater chance of getting people to pay attention to your mailing, thus lifting response."

From the cover to the last word, Kikoler wrote and designed this magalog to get readers to see themselves everywhere and feel hope. To get them to identify with other ordinary independent business people flailing around, trying to make it, and finding the solution.

Magalogs, Kikoler says, are more linear in development than the classic package—the reader is more likely to start at page one and move to the end. Here, the letter from Michael Gerber on the white pages pulls the reader along, but everywhere else there are compelling stories, sidebars, tests and lists. The boxes and copy blocks create energy and add excitement with something new on every page.

Throughout the piece, you see devices that say "a human being touched this." On the cover alone, there's the hand-drawn circle on the note, which is covering the photos ("see inside" to see the full faces), and the boxes that break into the border and bleed toward the inside of the book. These kinds of "planned imperfections" invite involvement. "The eye zeroes in on things that are out of place in terms of color, size, position," Kikoler says.

The product itself is not shown until page 19. By then, it's almost superfluous. What counts is that the reader knows he is understood . . . deeply.

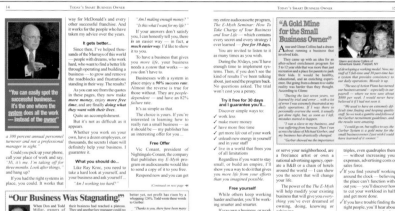

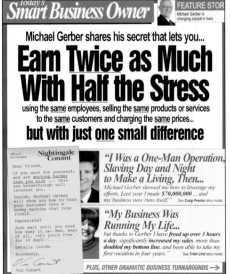

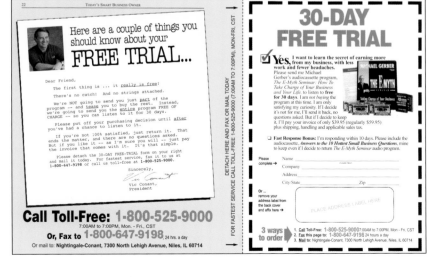

Start where people are. Then they will read the next sentence and the next. . . . "There must be an easier way to make a living!" starts it all in this package designed and written by Kikoler. To signal "This is about money," he scanned a one-dollar bill to use at the top of the letter.

Kikoler says he writes and designs for the person who hates advertising and hates to read. (Kikoler says he himself failed English, has a very limited vocabulary, and gets all his news from CNN and the radio.)

He knows that even people who don't want to read will read typewriter fonts and handwritten annotations. He keeps it simple, designing for that person with whom the copy resonates. He knows the person he's designing for here is willing to read an eight-page letter (the white areas) when it's presented like this—combined with an eight-page brochure (on light yellow).

Then there are the human touches. The faux-certificate order form looks as if the product name and the offer were typed in by someone in the office. There's a last-minute "stamped" message. Note the asterisk next to the "30-Day Free Trial" and the very low-key acceptance copy it references.

"There must be an easier way to make a living!"

There is! While most people live lives of frustration — trading their hours for dollars — thousands of others have discovered **the secret of making money _without working for it_.** See my special report inside to learn how.

Vic Conant
President
Nightingale-Conant
Corporation

If you hurry, you can try it free for 30 days!

30-Day Free-Trial
CERTIFICATE

This certificate entitles you to receive: "Multiple Streams of Income: How to Generate a Lifetime of Unlimited Wealth" by Robert G. Allen to listen to for a period of **30 days at NO CHARGE**

To accept, please check here: ☐ Yes, I accept my **30-Day Free Trial***

*I am _not_ buying Multiple Streams of Income at this time. By saying yes, I am only satisfying my curiosity and agreeing to borrow it _free for 30 days_. If during that time I find it is not for me, I'll send it back. No questions asked. If I decide to keep it, I will honor your invoice of only $59.95 plus shipping, handling, and applicable sales tax.

Ship Free Trial To:

FOR FASTER SERVICE, CALL TOLL-FREE:
CALL: 1-800-525-9000
OR, FAX THIS CERTIFICATE TO
FAX: 1-800-647-9198

Are you one of those people who hate their jobs but are "hooked" on getting that weekly fix of the steady check?

If so, here's the secret of breaking free ...

Vic Conant's SPECIAL REPORT

IF YOU WANT A LIFETIME OF UNLIMITED WEALTH, THIS NEW INFORMATION FROM ROBERT G. ALLEN WILL BE AN EYE-OPENER.

Robert G. Allen asks ...

"Do you want to be financially free?
"Do you want to end your money pressures forever?
"Do you want to double your income?
"Do you want to build a lifetime stream of income?
"If you said yes, do you know how to make it happen... this year?"

In this special report, you'll discover how a simple method is helping thousands of people create streams of money flowing to them for the rest of their lives — with no employees, no selling, little or no start up cash, little or no risk and no inventory.

Dear Friend,

Imagine the impossible -- making money without working for it.

Did I say impossible?

Well, it's not. Not anymore.

Right now, thousands of people are discovering that they can make twice as much money without working, or, at the most, work half the hours they used to.

Picture this ...

Suppose you take tomorrow off and spend it as you wish. Not a care in the world. Nothing stressful on your mind. You fill your day doing things you want to do -- instead of what others want of you.

Maybe you'll spend your time on the golf course, play tennis, relax by your pool, go fishing with your kids, sail with a friend, shop, browse through record stores, read a book or polish your car.

At the end of the day, something out of the

(over, p...)

▼ 30-DAY FREE TRIAL ▼

How to make an easy $500,000 on the Internet

Call Toll-Free 1-800-525-9000

▼ 30-DAY FREE TRIAL ▼

The secret of teaching killer whales?

FREE LAND!

Call Toll-Free 1-800-525-9000

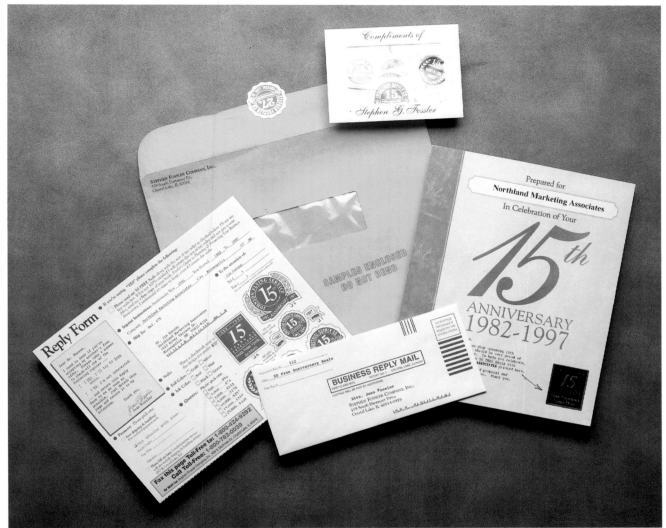

This mailing, promoting embossed foil anniversary seals, is aimed at owners of companies that are coming up on milestone anniversaries (fifth, tenth, twenty-fifth, etc.). The appeal is to the owner's pride.

Designed and written by Kikoler, this package has a no-nonsense feel. The kraft paper envelope is businesslike and "Samples Enclosed" ensures it will be opened. The seal used on the back of the envelope is the best possible "headline" and has the added benefit of demonstrating the product.

Inside are the complimentary seals (presented in an invitation-size envelope with a large window) and a personalized "proposal," actually a four-page letter with a cover. The inside cover of the proposal shows the family behind the family-owned and -operated Stephen Fossler Company, along with testimonials from happy customers. On the back cover is the Reply Form, which has to be very clear because of the complexity of the order. The note from Jean Fossler on behalf of her brother states very clearly what she wants you to do——now. And it stands out on the page like a sore thumb. Kikoler designed the form so that it looks as if "someone in the office" typed in personalized information. It creates the feeling that Jean is sitting waiting for your order.

Glossary

ACCEPTANCE STATEMENT—Copy usually appearing on the order form that stipulates agreement to the terms of the offer.

ANXIETY RELIEVER—Copy intended to reduce the risk of ordering, such as "Examine for fifteen days and return if not fully satisfied."

ASPECT RATIO—The dimension of a mailpiece expressed as a ratio of height to length.

AUTOMATION BASIC RATE—The highest single piece rate for First-Class and Standard mail meeting automation standards. To qualify for automation rates, mailpieces must meet USPS requirements for size and materials, be addressed correctly and pre-barcoded before being submitted to the USPS, as well as meet USPS regulations for processing (traying, etc.) and paperwork submission.

BENEFIT—People don't buy products or services, they buy benefits. Benefits are how the product or service makes buyers money, saves them time, makes them more successful, makes their lives better.

BIND-IN—A promotional piece bound into a magazine. Generally contains ad copy with a perforated reply or order form usually on card stock.

BLOW-IN—Similar to a bind-in, but this is that piece that usually falls out of a magazine since it is not attached in any way. It's literally blown by a machine between the pages.

BOOKALOG—A combination book and catalog. There's a lot of text like in a book, yet a product or service is being sold like in a catalog. Usually digest size, 5" x 7".

BRC (BUSINESS REPLY CARD)—A postage-paid and preaddressed promotion reply card. The mailer pays First-Class postage plus a per-piece fee for each returned BRC.

BRE (BUSINESS REPLY ENVELOPE)—A postage-paid and preaddressed promotion reply envelope used for orders, payments, inquiries, etc. The mailer pays First-Class postage plus a per-piece fee for each returned BRE.

BRM (BUSINESS REPLY MAIL)—BRM is a system by which postage is paid by the mailer on mail (envelopes, cards, cartons) returned by customers. The mailer pays initial and annual fees for a BRM permit.

BRMAS (BUSINESS REPLY MAIL ACCOUNTING SYSTEM)—Participants in BRMAS (typically large-volume mailers) are assigned unique four-digit codes that are specific to postcards, one-ounce letters and two-ounce letters. Added on to a BRM permit barcode, these codes enable the USPS equipment to sort, count and rate BRM and assign the costs to the customer's account automatically.

BUCKSLIP—Small inserts (usually about the size of a dollar bill or "buck") added to a mailing package. Commonly used to tout any freebies, early-bird offers, or testimonials or to separately list top benefits and reasons for responding.

CONTINUATION—Mailing list that a mailer continues to use after the initial test of the list proves successful.

CONTROL (CONTROL PACKAGE)—The mailing against which test package results are compared. It's the package that has won in previous tests. It sets the benchmark.

CREATIVE—In direct mail parlance, the design and copy embodied in the mailpiece.

DOUBLE POSTCARD—A relatively inexpensive direct mail piece, but limited in copy space. Half contains ad copy and is addressed to the recipient and the other half is an order or reply form, always a business reply card. Currently can be mailed at First-Class presort postcard rates.

DROP DATE—The date a mailing enters the mail system.

DRY TESTING—Testing the response to a product or service before it is actually produced and/or available for sale. This is generally done for products/services with high start-up costs or other high risks.

ELEMENT TESTING—A test of one variable or element in a mailing—for example, testing if a mailing does as well with a brochure as without, or if one envelope beats another.

ENVELOPE MAILING—A direct mail format that consists of an outer envelope containing various elements—letter, reply form, brochure and inserts.

EYE-PATH—The sequence in which a reader's eye is pulled to the copy, images and other parts of a design.

FACILITATOR—Anything that makes it easier for the reader to respond, such as an 800 number, postage-paid reply card, fax number or terms of payment like "Bill me later."

FEATURE—An attribute of a product or service that makes it appear useful and attractive to a customer. A timer might be a feature of a coffeemaker.

FIM (FACING IDENTIFICATION MARK)—Machine-detectable series of vertical bars printed in the upper middle portion of business reply mail as an orientation mark for automatic facing and canceling equipment.

FIRST-CLASS PRESORT RATE—Discounted First-Class postal rate that applies to automation letters and flats prebarcoded, sorted in ZIP code order and prepared according to postal regulations for traying, rubber banding, bagging, etc.

FIXATION—Pause of the eye for about one-tenth of a second during a reading sweep, when actual perception of the word takes place.

FLAT—First-Class or Standard mail whose height is between 6 and 12 inches, whose length may be between 5 and 15 inches if 6 to 7½ inches high and between 6 and 15 inches if over 7½ inches high and which may be between .009 and ¾ inch thick and/or does not comply with the aspect ratio of between 1.3 and 2.5. (Flats cost more to mail than letter-sized mail, i.e., mail that falls between 3½ and 6⅛ inches in height and 5 and 11½ inches in length and whose length divided by height—the aspect ratio—falls between 1.3 and 2.5.)

FREEMIUM—A premium that comes in the envelope with the offer. No purchase is required.

INDICIA—A preprinted marking on a piece of bulk mail used when the postage has been prepaid by the mailer as per authorization by the USPS. A permit is required and an annual fee.

INSERT—A piece in a direct mail envelope package that is in addition to the letter, brochure, order form and BRE. Buckslips, coupons and lift notes are examples of inserts. In a more general sense, anything to be inserted in an envelope.

INVOLVEMENT DEVICE—Something in the mailing package that gets the reader physically involved. Some examples are peel-off tokens, scratch-offs, punch-out pieces, stamp sheets and placing a token in a slot.

KEY CODE—A numeric or alphanumeric code (most frequently placed on the reply form) used to track the response rates of an

offer, list, a particular coupon, catalog, etc.

L-SHAPED RESPONSE DEVICE—A response card shaped like the letter L where the part the responder returns is torn away from the ascender.

LAUNCH—The introduction of a new product/service to the public. Often accompanied by a great deal of promotion in a variety of media to build awareness and interest.

LEAD—Someone who has expressed interest in a product/service, perhaps in reply to a lead-getting mailing or via a survey or questionnaire.

LEAD-GETTING MAILING (LEAD GENERATOR)—A mailing designed to get responses from interested people who need to be actually sold via another method, such as personal sales or telemarketing. Usually the product or service being pitched is complex or expensive.

LETTER-SIZED MAIL—Mail that falls within USPS maximum and minimum size and thickness ranges: no smaller than $3^{1}/_{2}$" x 5", no larger than $6^{1}/_{8}$" x $11^{1}/_{2}$", and between .007 and ¼ inch thick and whose length divided by height (the aspect ratio) falls between 1.3 and 2.5.

LIFETIME VALUE OF A CUSTOMER—The total profit or loss (actual or estimated) from a customer during the time he/she remains a purchaser of a product or service.

LIFT LETTER—An insert used to "lift" response. It's often the size of a note paper and presented as a second letter with a different signer than the main letter.

MACHINABLE MAIL—Direct mail packages that meet USPS size, materials and addressing requirements to be processed automatically by postal service equipment.

MAGALOG—A direct mail format that's a combination magazine and catalog. Essentially a self-mailer. Copy is laid out in articles, helpful tips and bulleted lists of benefits or "secrets" that will be revealed when you purchase the product.

OCR (OPTICAL CHARACTER RECOGNITION) AREA—Locations for appropriate placement of scanner readable symbols, numbers and letters for automatic processing by USPS optical character reading equipment.

OFFER TESTING—A promotion test to compare response to different prices, terms, quantities, etc.

OSE—Short for outside envelope.

OUTER—The outside envelope used to carry the pieces of a direct mail package. Its purpose is also to create enough interest (via teaser copy, graphic devices such as die cuts or action devices such as a pull tab) to get the package opened.

PACKAGE TESTING—Testing of a new package against the existing control.

PASSALONG—Happens when a direct mail piece gets "passed along" to someone other than the addressee. For example, a manager may pass a seminar mailer along to an employee.

POSTERBOARD—A direct mail format where the order card is attached/glued to a card stock that's roughly $8^{1}/_{2}$" x 11" and the whole piece is sealed in clear plastic. Sort of like a big, two-sided, plastic-wrapped postcard.

POSTNET (POSTAL NUMERIC ENCODING TECHNIQUE)—The barcode used to encode ZIP code information.

PRICE TESTING—Similar to offer testing, but testing only the price. All other elements must remain the same.

PROSPECT—A potential buyer of a product or service who hasn't bought the product or service before but is thought likely to respond to a mailing.

READABLE MAIL—Letter mail with machine-printed optically scannable addresses that can be read by post office equipment. The USPS gives the biggest discounts to mail that meets its standards for addressing and prebarcoding.

RELATIONSHIP MARKETING—Sending frequent, regular mailings to establish favorable recognition and loyalty, which in turn should increase response to offers and Lifetime Value of a customer.

RESPONSE DEVICE—Any format that motivates a response, including order forms, coupons, gift certificates and surveys.

ROLLOUT—The first or biggest mailing of a package in a direct mail campaign. Usually done after a successful test mailing to the same lists.

SELF-MAILER—A direct mail piece designed to be mailed without an envelope.

SIC (STANDARD INDUSTRIAL CLASSIFICATION)—A four-digit numeric code established by the U.S. government to designate industries by their functions and products; can be used to segment lists and to target promotions.

SINGLE-VARIABLE TESTING—Isolating one variable to test, leaving everything else about the mailing the same. Allows the mailer to see clearly the effect of the change on mailing results.

SOFT OFFER—An offer to review the product first and then either pay for or return the product. Commonly used in magazine subscription offers.

STANDARD BULK MAIL—A minimum of two hundred identical pieces (or fifty pounds) mailed together that qualify for a discount on postage because the USPS handles this mail slower than First Class.

SWEETENER—Added inducements to persuade the reader to accept the offer or act more quickly, such as, "Buy within ten days and get an extra 10 percent off!"

TAP TEST—A test the USPS may perform to determine if the address and bar code in a window-envelope mailing stays within the window and meets USPS guidelines for machine readability. If any one piece in the mailing fails, the entire mailing may be disqualified for automation rates.

TEAR-OFF STUB—A portion of a reply form that gets torn off, usually because the size of the reply form has to be reduced to fit in the BRE.

TEASER COPY—Copy on the front of the outer envelope that motivates the reader to open it and read the contents inside: "Valuable Coupons Inside," "Dated Material," or "You Could Be A Winner!" More generally, copy that arouses curiosity rather than promises a benefit.

TRAFFIC GENERATOR (TRAFFIC BUILDER)—A direct mail piece designed to attract customers to a store or other retail site. May offer an added incitement such as a special discount coupon or advanced sales notice.

TRANSACTION FACILITATOR—Anything that helps the reader to act on the offer, such as credit card payment or a "bill me later/send no money now" option.

USPS—United States Postal Service.

WEAR OUT—The decreasing effectiveness of a winning direct mail package over time.

Permissions

p. 11 © Blum & Co. and *PC Ratings*

p. 19 © David Wise and Time Life Books

p. 20 © Richard Browner and World Book Encyclopedia

p. 24 © Meredith Corp.

pp. 26-27 © David Gordon Associates, Inc. and Men's Journal Company

p. 29 © Segura Design and [T26]

p. 29 © Imagine Media

p. 30 © CHEUNG /CROWELL Design Studio and Claritas

p. 31 © Mary Pretzer

p. 32 © David Gordon Associates, Inc. and client

p. 33 © Jager DiPaola Kemp Design and Backhill

p. 35 © Jayme, Ratalahti, Inc. and *Saveur* magazine

p. 39 © David Wise and *Horticulture* magazine

p. 39 © David Wise and *BYTE* magazine

p.39 © David Wise and Oxmoor House

p. 40 © Rodale Press, Inc.

p. 41 © Jyl Ferris and *Vogue* magazine

p. 41© Rodale Press, Inc.

p. 46 © F&W Publications

p. 48 © David Wise and F&W Publications

p. 52 © Meredith Corp.

p. 53 © David Wise and F&W Publications

p. 54 © Ron Marshak Direct Marketing and Sears Auto Club

p. 56 © CHEUNG/CROWELL Design Studio and *Archive* magazine

p. 59 © Ted Kikoler and client

p. 61 © Meredith Corp.

p. 62 © Ron Marshak Direct Marketing and EATON/Petro-Canada

p. 63 © Nika LLC and NFO Interactive

p. 64 © Ted Kikoler and Nightingale Conant

p. 68 © Meredith Corp.

p. 72 © Richard B. Browner and client

p. 74-75 © Meredith Corp.

p. 75 © David Wise and *Utne Reader*

p. 76 © Blum & Co. and Pitney Bowes DirectNET Mailing Services

p. 77 © CHEUNG/CROWELL Design Studio and Gevalia Kaffe

p.77 © David Wise and F&W Publications, Inc.

p. 81 © Rodale Press, Inc.

p. 82 © Rodale Press, Inc.

p. 82 © David Wise, Wise Creative Services, Ltd.

p. 82 © Meredith Corp.

p. 83 © David Wise and Oxmoor House

p. 87 © Concrete and Tony Stone Images

p. 88 © Imagine Media

p. 88 © Stoltze Design, Inc.

p. 89 © Mary Pretzer

p. 90 © CHEUNG/CROWELL Design Studio and client

p. 91 © Rodale Press, Inc.

p. 94 © David Gordon and *Saveur* magazine

p. 97 © Nika LLC

p. 99 © 1994 Sayles Graphic Design and J. C. Nichols Company

p. 100 © Concrete and Hinge

p. 101 © Love Packaging Group and the Mental Health Association

p. 102 © 1997 Love Packaging Group and client

p. 103 © Hornall Anderson Design Works, Inc. and GE Capital Assurance

p. 104-105 © Cahan & Associates and GVO

p. 109 © Jayme, Ratalahti, Inc and *The New Yorker*

p. 110 © Jayme, Ratalahti, Inc. and the Library of Congress

p. 111 © Jayme, Ratalahti, Inc. and *Commentary* magazine

p. 113 © Rodale Press, Inc.

p. 114 © Rodale Press, Inc.

p. 115 © Rodale Press, Inc.

p. 117 © Richard B. Browner and *Texas Monthly* magazine

p. 118 © Richard B. Browner and *Cross Country Skier* magazine

p. 119 © Richard B. Browner and *Camera Arts* magazine

p. 121 © Meredith Corp.

p. 122 © Meredith Corp.

p. 123 © Meredith Corp.

p. 125 © David Gordon Associates, Inc. and *Martha Stewart Living* magazine

p. 126 © David Gordon Associates, Inc. and *Discover* magazine

p. 127 © David Gordon Associates, Inc. and *Esquire* magazine

p. 129 © Jyl Ferris and *nest* magazine

p. 130 © Jyl Ferris and *American Homestyle & Gardening* magazine

p. 131 © Jyl Ferris and *Health* magazine

p. 133 © David Wise and Meredith Corp.

p. 134 © David Wise and Time Life Books

p. 135 © David Wise and Southern Living Books

p. 137 © Ted Kikoler and Nightingale Conant

p. 138 © Ted Kikoler and Nightingale Conant

p. 139 © Ted Kikoler and Steven Fossler Company, Inc.

INDEX